Ulukhaktok

Cambridge Bay

Taloyoak

Kugluktuk

Gjoa Haven

Kugaaruk

Umingmaktok

Bathurst Inlet

NUNAVUT

NORTHWEST
TERRITORIES

Cape Dorset

Yellowknife

ALBERTA

SASKATCHEWAN

MANITOBA

ONTARIO

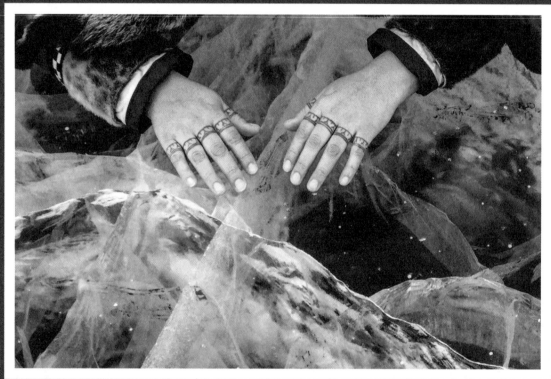

meta antolin

REAWAKENING
Our Ancestors' Lines:
Revitalizing Inuit Traditional Tattooing

Brought to life and compiled by Angela Hovak Johnston

The author thanks the following organizations for their generous support of the original Inuit Tattoo Revitalization Project:

 Takikyoak IBA Heritage Committee

Published by Inhabit Media Inc.

www.inhabitmedia.com

Inhabit Media Inc. (Iqaluit) P.O. Box 11125, Iqaluit, Nunavut, X0A 1H0

(Toronto) 191 Eglinton Ave. East, Suite 301, Toronto, Ontario, M4P 1K1

Design and layout by Meta Antolin copyright © 2017 Inhabit Media Inc.

Cover design by Astrid Arijanto

Text copyright © 2017 by Angela Hovak Johnston

Photography copyright © 2017 Cora DeVos of Little Inuk Photography (except where noted)

We acknowledge the support of the Canada Council for the Arts for our publishing program.

This project was made possible in part by the Government of Canada.

ISBN: 978-1-77227-169-0

Printed in Canada.

Library and Archives Canada Cataloguing in Publication

Johnston, Angela Hovak, 1975-, author

 Reawakening our ancestors' lines : revitalizing Inuit traditional tattooing = Atuffaalirniq hivunipta kakiniinnik / brought to life and compiled by Angela Hovak Johnston.

Text in English only.

ISBN 978-1-77227-169-0 (hardcover)

 1. Tattooing--Canada, Northern. 2. Inuit women--Canada--Social life and customs. 3. Inuit--Canada--Social life and customs. 4. Inuit women--Canada. I. Title. II. Title: Atuffaalirniq hivunipta kakiniinnik.

E99.E7J6 2017 391.6'5089971 C2017-904002-2

Atuffaalirniq Hivunipta Kakiniinnik

Table of Contents

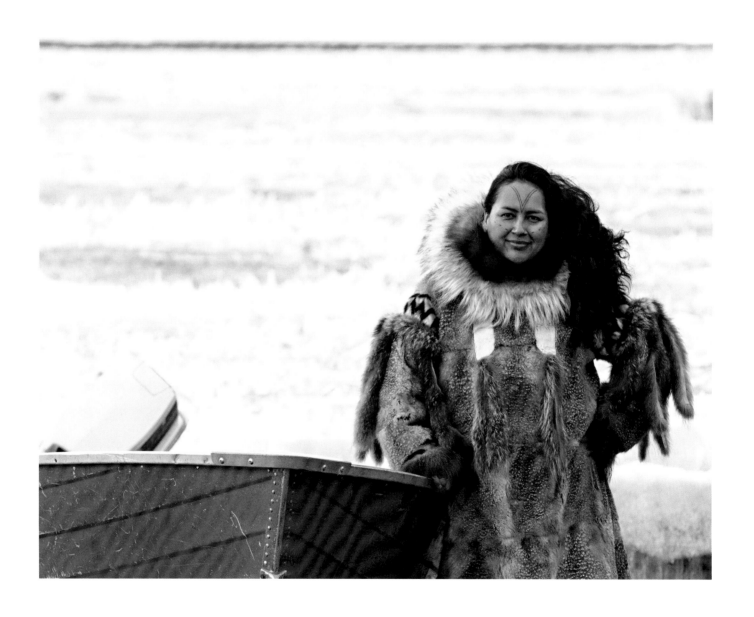

Introduction

by Angela Hovak Johnston

I would like to acknowledge the following sponsors. Without their support this project would not have been possible: the Takikyoak IBA Heritage Committee, the Canada Council for the Arts | Conseil des Arts du Canada, Dominion Diamond Ekati Corporation, Yellowknife Super 8, the Hamlet of Kugluktuk, Coppermine Inn, Kikiak Contracting Ltd., and the Northern Arts and Cultural Centre. I also have to offer a special thank you to Leela Gilday for all her help during the project.

I would also like to pay my respects to our elders, the tundra *nuna*, the sea, the wind, our ancestors, our people now, and the generations to come. Most importantly, I recognize and thank the women who wore the markings before us, who were so strong in carrying this tradition.

This eight-year project began with my personal journey to permanently ink myself with the ancient symbols that were worn by my Inuit ancestors. The last known Inuk woman in the Nunavut area with tattoos done the traditional way passed away in 2005; that is when my passion grew. Knowing she was the last inked Inuk woman, I strongly believed tattoos couldn't become just another part of history that we only read about in books, so I pushed forward with my dream of having tattoos. I knew I had a role to play. It took me years of hard research and finding the right tattoo artist to do these markings on my face. Not giving up, in 2008, I finally had my first facial tattoos. Inuit traditional tattoos, almost lost as a result of missionaries and residential schools, have come back. While tattoos skip three generations in some families, through this project, we thankfully had the pleasure of inking a family of women who carried three generations of new tattoos.

Because it was so difficult for me to find an Inuk tattoo artist, as no one has been practising since the early 1900s, when most tattoo artists were respected seamstresses, I decided I would take on the challenge to learn ancient, modern, and contemporary techniques. I have watched and asked many questions regarding tattooing. The ancient methods I learned from different elders were from stories they had heard, but never actually seen in practice—for example, the use of an animal-bone needle and a piece of caribou sinew, the end of which was soaked in seal oil and soot for ink. The modern twist to this method is to replace the bone needle with a metal one, the sinew with cotton thread, and the oil and soot with ink. The process remains essentially the same, however: the needle stitches through the skin and the thread leaves ink inside the skin. The ancient poking technique uses a stick and a needle to poke the ink into the skin. Once again, metal replaced bone for this project.

I started my tattoo artist experience with the contemporary gun technique. From the beginning to the end of this project, I learned the three techniques: stitching, poking, and gun. I think that I was ready to test my skills as a tattoo artist because I've always had good hand-eye coordination and enjoy working with skins to design traditional art. I also enjoy being creative in my artwork. I love challenges. I have strong cultural beliefs and use traditional knowledge for guidance. I'm willing to be an advocate for our women; it's our responsibility to carry our traditional practices so we can be connected, grounded, and constantly reminded of where we come from.

The project took over my life, and I therefore thank my husband for his encouragement, for giving me the time to work on it, and I also thank him and my children for so generously granting me their patience.

I am so grateful for and honoured by the women who put their trust in me, all the Inuit women who strongly believed in being tattooed by an Inuk woman and who graciously allowed themselves to be the first. I hope to tattoo generations of women and to pass on the knowledge and skills to continue the tradition. I have sincere gratitude for Marjorie, a traditional tattoo artist from Alaska, and Denis, a contemporary artist from Yellowknife, who came to Nunavut with us. They are very talented artists who generously taught me so that our Inuit tattoos will never be close to extinction again. It was a privilege to be taught by them!

Inuit history was not written; a lot of the history was shared orally, traditionally through stories and songs—many of which were lost and almost forgotten, as they were forbidden and deemed shameful. For our research, we relied on elders' memories, stories, old museum photos, old explorers' documents, and publications. It was difficult for some of the women who participated to find the meanings behind traditional tattoos, so most have made their own personal meanings for their markings, with similarities to the old ones. Some women chose designs that were tied to their family, like those who have replicas of their grandmother's, great-grandmother's, or namesake's symbols tattooed onto their bodies. Still others opted to place significance on the process, rather than on the symbols they wanted. These tattoos are not only for beauty; they are extremely personal. The designs carry strong inspiration and identity from our ancestors as we tread into our future. They remind us of where we come from and who we are. Each tattoo is meaningful and special to the woman wearing it.

The stories we share here are the personal journeys of the modern Inuit women who inherited the right to be tattooed for strength, beauty, and existence, and to reclaim our history. The tattoos are a statement of who we are and where we come from. In my homeland, only women had traditional tattoos. Most markings represented beauty, significant life accomplishments, rites of passage, and womanhood. It has taken me a lot of time, thought, and research to find my own tattoos. They represent my self-identity and my children; they are my strength, my protection, and my guidance.

Sometimes I have been offended and annoyed when asked about my tattoos, only because they are so personal to me and I didn't feel like explaining myself; I felt disrespected. Now I'm open to sharing my story to educate and to pass on historical knowledge. We can feel our ancestors watching over us and smiling with pride. It's because of them that we have these beautiful traditions and cultural practices. I can feel my ancestors stirring within me, I hear many other Inuit longing for the opportunity and, most beautiful of all, I can sense the excitement of these women with so much strong passion. I've shed so many tears. I've experienced so many different emotions in knowing my project brought forth lots of healing and love.

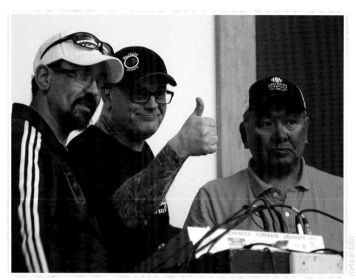

Denis gives a thumbs up after he successfully adjusts the sound system at the community feast with Kenneth Taptuna and Simon Kuliktana.

Denis Nowoselski

Born in Saskatoon, Saskatchewan, on March 22, 1967, I spent my early childhood years living throughout Canada, finally landing in British Columbia.

I decided it was time for a career change from cabinetmaker to tattoo artist in May of 1993 after almost losing three fingers in a table sander. I spent eighteen years tattooing on the west coast of Canada and travelling abroad to several other countries as a guest artist. I have won awards for tattooing at conventions in Canada.

I am also a musician and played music on five continents and in thirty different countries before retiring from the music industry in 2013.

In December 2011, I decided to leave the hectic life of Vancouver and moved to Yellowknife, Northwest Territories, where I have been actively tattooing since.

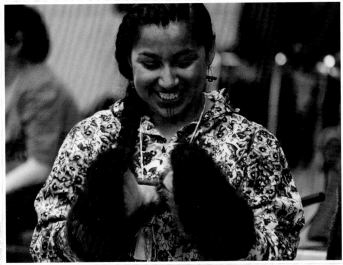

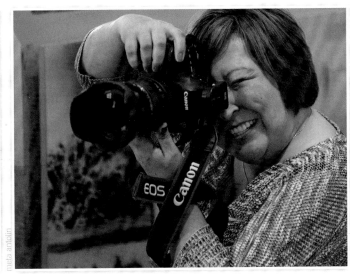

Marjorie enjoys the mittens presented to her at the community feast.

Marjorie Tahbone

I am Marjorie Tungwenuk "Kunaq" Tahbone. My parents are Carleton and Sandra Tungwenuk Tahbone of Nome, my siblings are Toh-Cyah-Day-Mah, Adele, Vanessa Tahbone, and Dana Thomas. My maternal grandparents are Lillian and the late Linne Rose of Nome, and my paternal grandparents are the late Marjorie and George Tah-Bone of Oklahoma. My namesakes are my grandmother Marjorie and my great-aunt Kunaq of Wales, Alaska.

I was raised living a subsistence lifestyle, which has influenced my goal of becoming a cultural bearer. In the diverse community of Nome, Alaska, where three major Inuit cultures reside—the St. Lawrence Island Yupik, the Inupiaq, and the Central Yup'ik—I have been able to acquire the knowledge and skills necessary to carry out my Inupiaq cultural values. My daily life consists of putting up native foods, creating traditional clothing and tools, and participating in native dance and games.

Although I identify as Inupiaq, I am proud of and acknowledge my roots as both Inupiaq and Kiowa Native American and have had the honour to represent my people by being named Miss Indian World 2011–2012. This title enabled me to gain more knowledge and understanding of my own and other cultures and world views.

I am so pleased to be a part of the Inuit Tattoo Revitalization Project and to practise tattooing using the ancient techniques of skin stitching and hand poking. I have tattooed men and women across Inuit country, hoping to instill a strong cultural identity among those who receive them.

Cora DeVos

I am Cora DeVos, the owner of Little Inuk Photography. I am delighted whenever I am able to help a woman see in herself the beauty that her loved ones see.

My passion for photography started back in high school in Cambridge Bay, Nunavut. Hovak was my first subject. I'm sure that we kept the store in business in Polaroid film sales alone. Hovak is still one of my favourite people to photograph!

Being a part of the Inuit Tattoo Revitalization Project has been an amazing experience. The excitement and energy coming from the beautiful Inuit women during our week in Kugluktuk was overwhelming; you couldn't help but feel that things were changing for our people and that there was a pride in our culture being reborn. This project was life changing for everyone involved, and I am honoured that I was chosen to share the stories through photographs.

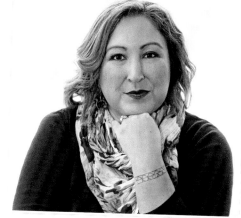

To wrap up my participation in the project, I received my own wrist tattoo, which meant the world to me. My best friend, of whom I couldn't be more proud, gave me my tattoo, bringing me closer to my culture than I could ever imagine.

When I look at my tattoo, I feel the beauty of our culture and the pride of being an Inuk woman, of my family, of my best friend—and I remember the amazing week I spent with these wonderful women. The tattoo and the experience will always be a part of me.

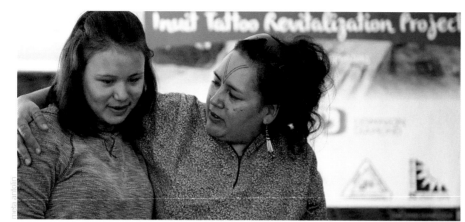

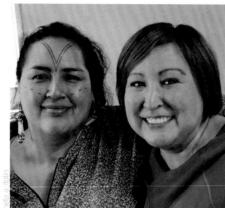

For five days in April 2016, Angela Hovak Johnston and her team converged at the Kugluktuk Heritage Visitor Centre in the Hamlet of Kugluktuk, Nunavut, to launch the Inuit Tattoo Revitalization Project.

The boardrooms and museum spaces of the centre became the tattoo parlour and photo studio for the project.

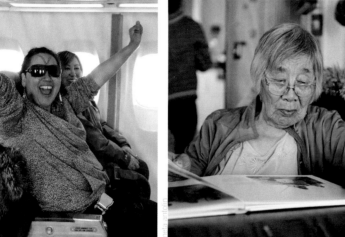

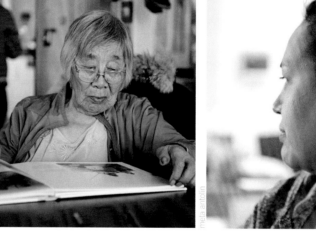

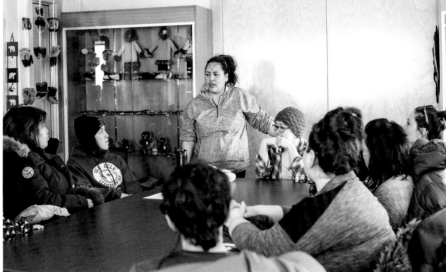

Hovak prepares the women for the project with words of encouragement and thanks.

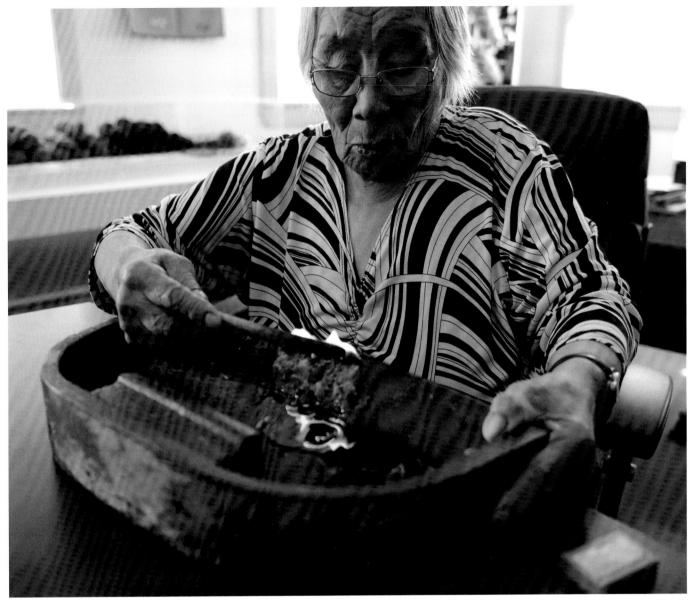

Elder Alice Hitkoak Ayalik was essential to the revitalization project, sharing her knowledge, wisdom, and humour as woman gathered at the Kugluktuk Heritage Visitor Centre.

The *qulliq*, a traditional Inuit lamp used for cooking, heat, and light, was essential to Inuit survival.

Here, Hitkoak demonstrates how to mix and mend the Arctic cotton and oil (traditionally seal oil) to control the burning flame.

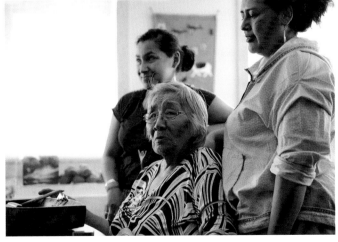

Alice Hitkoak
Ayalik teaches
Janelle Angulalik
how to drum.

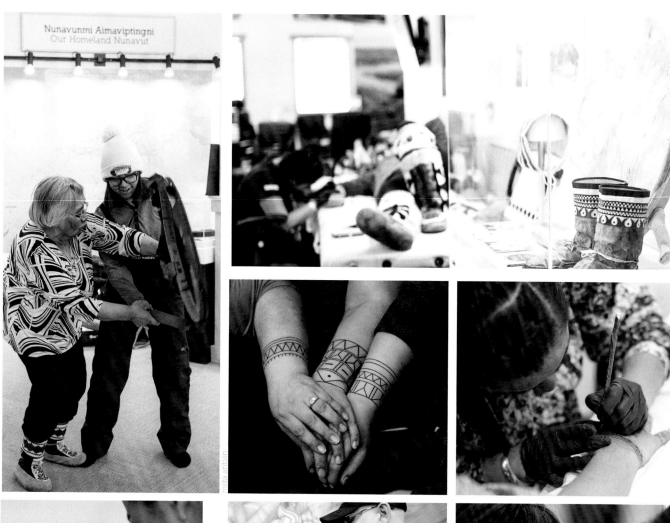

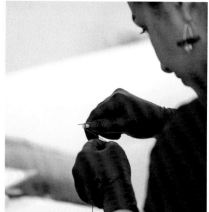

Marjorie and
Denis prepare the
tools for their work.

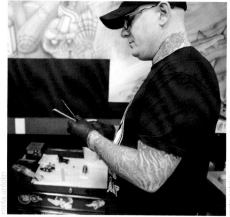

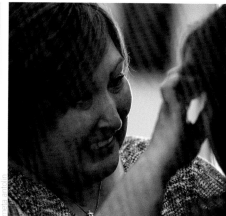

The project
photographer,
Cora DeVos, has a
gift for empowering
her subjects to feel
their own beauty
and capturing it in
photos.

Marjorie instructs Hovak on traditional tattooing methods.

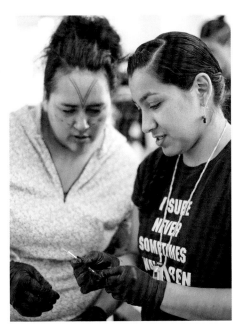

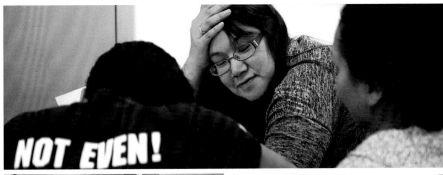

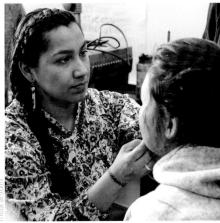

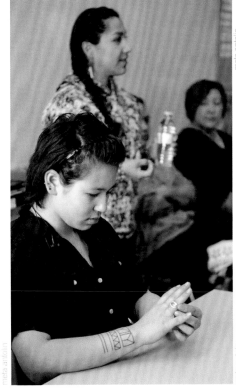

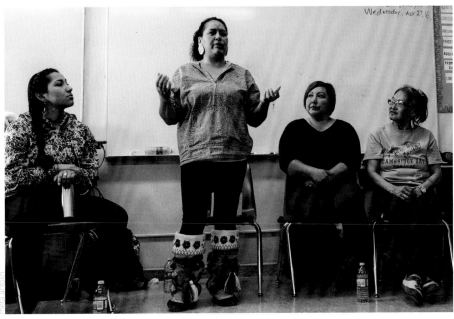

The Kugluktuk High School invited Hovak, Marjorie, Cora, and Millie to share their personal journeys that brought the project to life.

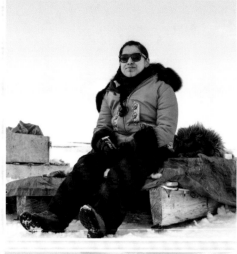

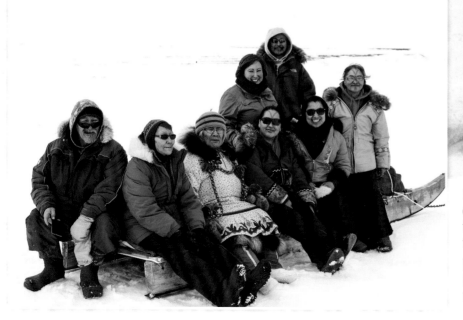

Days at the centre were emotional as woman after woman took the courageous step of reclaiming this Inuit tradition. Hovak arranged an ice-fishing outing for the team to recharge their batteries and enjoy amazing traditional food.

From left to right in the group photo: Richard Akana, Sharon Ilgok, Alice Hitkoak Ayalik, Angela Hovak Johnston, Marjorie Tahbone, and Millie Navalik Angulalik, with Cora DeVos and Donny Kamoayok in the back.

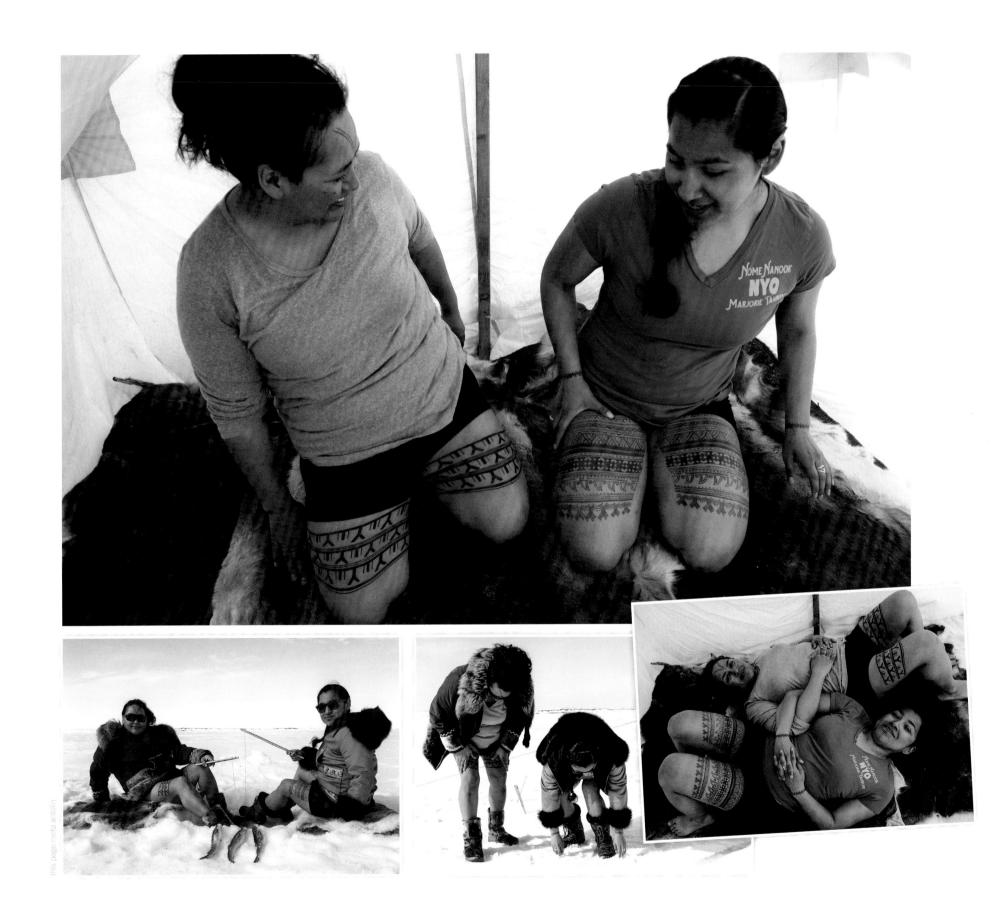

Adele
Starr
Ohokak

The three lines I want on my chin represent me and my siblings. The lines on my wrist show the pride I have in being an Inuk woman and how much I cherish my culture.

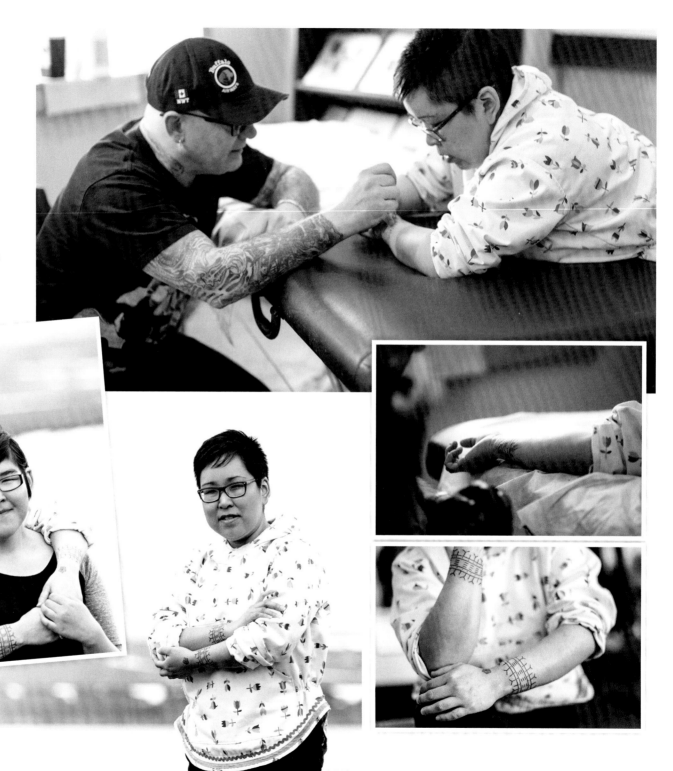

ⵁⵁⵁⵁⵁⵁⵁⵁⵁⵁⵁ REAWAKENING OUR ANCESTORS' LINES

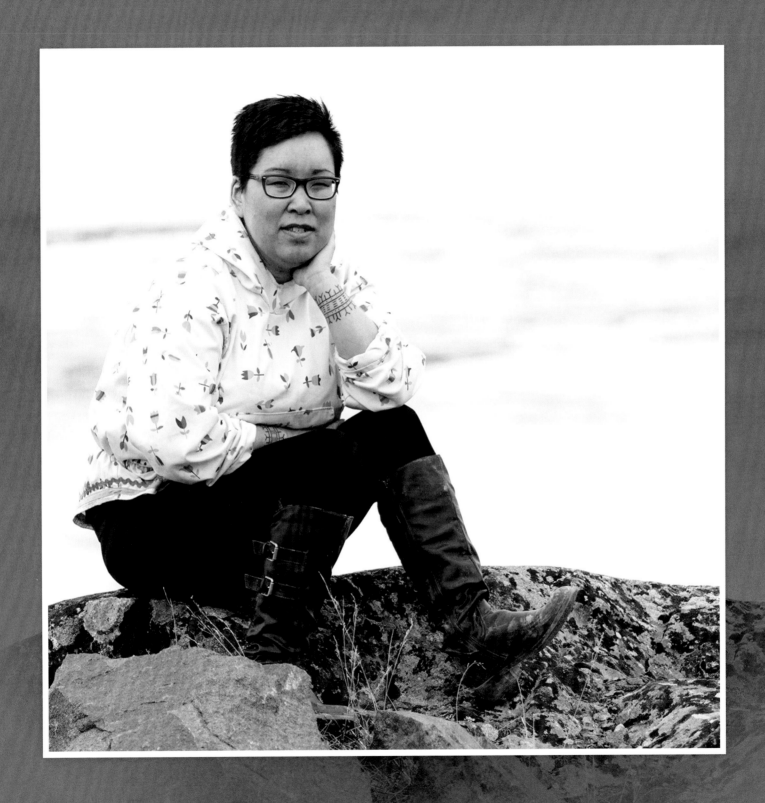

Alisa Hivaruq Praamsma

I was born in the south and later adopted into a non-Indigenous family. I often had feelings of not having an identity, being disconnected, lost, and not spiritually rooted.

When I gave birth to my first child, I finally understood what it meant to be connected to another human, and that connection was reinforced when my second child was born.

Most of my life I wondered about Inuit facial tattoos and was fascinated by them. When I moved north in the1990s, I would occasionally hear whispers about the generations before who had the markings—a proud rite of passage.

These tattoos symbolize two worlds coming together. The dots represent my two girls and my nieces.

Since I have been tattooed, I feel that I am finally coming into myself and that I belong. As a human, a mother, and a woman.

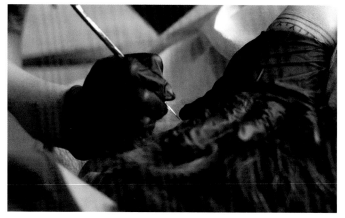

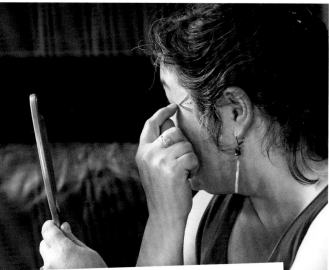

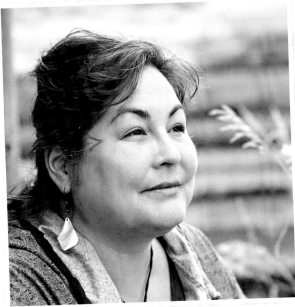

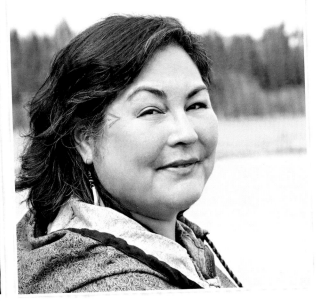

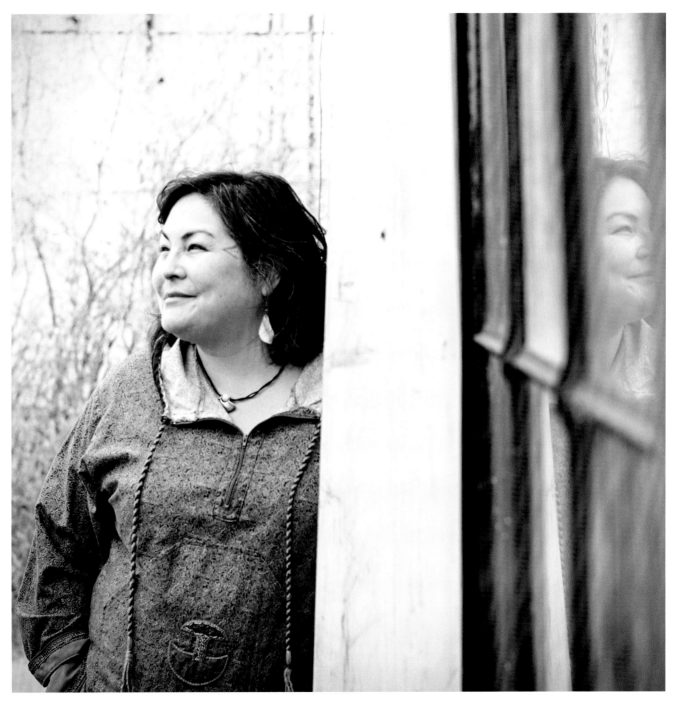

Angela Hovak Johnston

I currently live in Yellowknife, Northwest Territories, but I grew up in the little Inuit settlement of Umingmaktok (Bay Chimo). At the age of seven, I was sent away to the Federal Hostel at Cambridge Bay (residential school). I later started my family in Kugluktuk. I have an intense passion for my culture and a deep connection to my traditional roots. I try my best to pass on the traditional knowledge to keep it alive and going strong.

Many Inuit women have a strong yearning to carry their ancestors' marks and symbols and to feel more connected to their people, culture, and traditions. It's the root of healing and the beginning of a spiritual, empowering journey.

I always had a love for traditional tattoos, but my strong passion for tattoos started eleven years ago. After three years of hard research and many questions, I received my first facial tattoos eight years ago, in 2008. Now I have various tattoos. The Y symbols represent the Inuit seal-hunting tool made with caribou ligaments, and my Y markings all face down. I have sons, so the markings face downward because the men often leave the family when they marry and start a family of their own and usually go with the wife's family. The Ys that face up usually represent daughters, because they tend to stay close to their family.

Having experienced the difficulty of getting traditional tattoos and finding the right artist, I felt a longing to be tattooed by an Inuk woman. Unsuccessful and disappointed in not finding somebody in my culture who practised tattooing skills, it became my dream to learn the lost skills and become a tattoo artist myself. It was my goal to make tattooing available to Inuit women so they could carry on this tradition. I felt that it should be possible while there are so many talented, capable Inuit seamstresses who could fit the title.

I never gave up on my dream. It took eight years to plan, bring all the pieces together, and make it a reality. I put together a team consisting of a traditional tattoo artist, Marjorie Tahbone, from Alaska, and a contemporary artist, Denis Nowoselski, from Yellowknife. Marjorie passed her skills and knowledge of hand poking and hand stitching to me, and Denis taught me the modern technique with a tattoo gun. It was also very important to me to have an Inuk photographer to document the project for this book. I selected Inuk photographer Cora DeVos to work with the women; it was important to bring that trust of working with our people at all levels. It was also important to have an elder present for emotional support, because revitalization can trigger many difficult emotions. We had Elder Alice Hitkoak Ayalik participate in the project. We also had a community feast and celebration to involve the whole community in welcoming the women with their new tattoos.

My next phase and future goal is to mentor and teach these tattooing skills to other Inuit women across the North to ensure we have many other tattoo artists passing on the traditions, like in ancient times. Never again will these Inuit traditions be close to extinction, or only a part of history you read about in books. This is my mission.

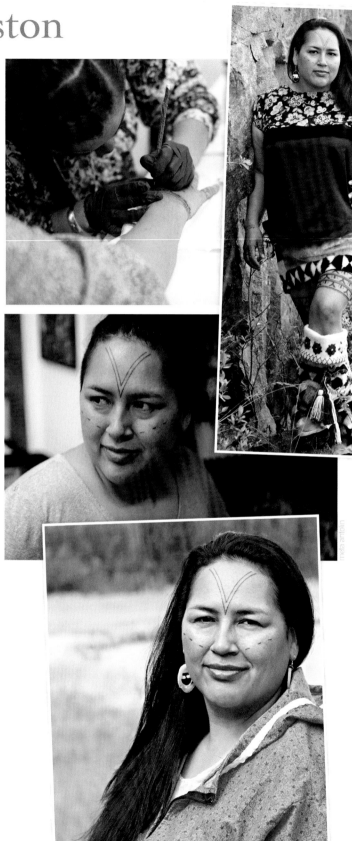

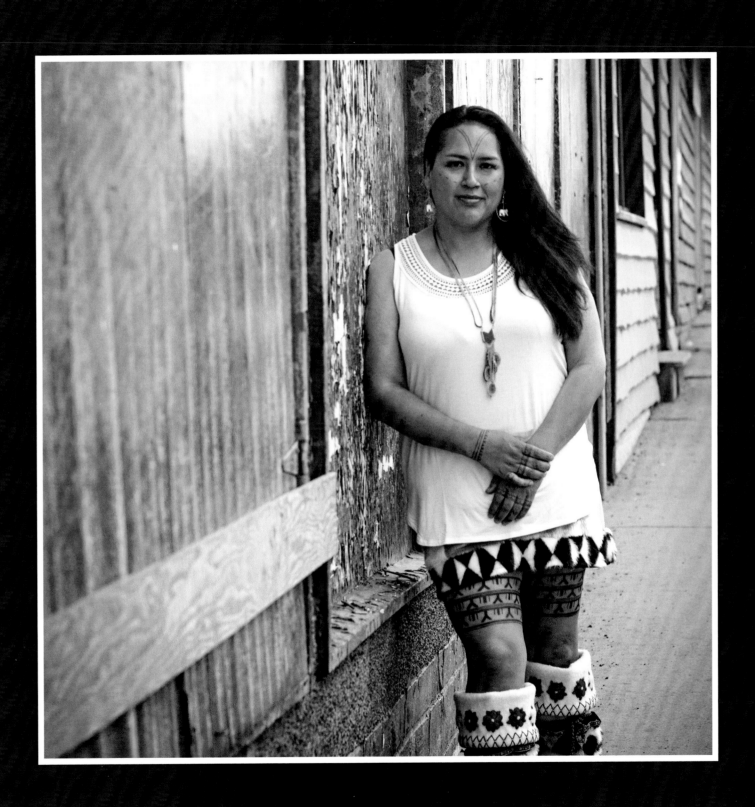

April Hakpitok Pigalak

I remember a time when I was a kid: we had an elder visit, telling stories. I don't quite remember the exact event or location, but the thing I will never forget was when someone asked the elder a question about a tradition, and she answered back in Inuinnaqtun. The translator said that it was something the elder didn't want translated or feel comfortable speaking about. The translator later said that it was something that Inuit were told to no longer practise.

I don't remember much detail about the topic, but I remember the look on her face. The moment of silence after she refused to speak of it. The feeling I felt. I was so young, but I had heard about times like this through my elderly adoptive parents' recollection of school and Western religion and not being able to speak their language or practise any of their traditions, and I felt a deep pain for them. To not be able to love who you are, to not carry pride in who you are and your culture, to not enjoy things once loved, traditions that once brought joy to families and friends.

I choose to be a part of this amazing movement of beautiful Inuit regaining a sense of what it means to be Inuk through different ways and to have pride in that. To no longer hesitate when passing on knowledge of Inuit traditions. To no longer hold back the joy that our traditions once brought us.

I feel so much pride and happiness to see Inuit women across the Arctic, even people I've never met, show tattoo patterns changing across the regions, meanings and stories being shared and learned through the designs. I am so thankful to be able to be a part of this project.

I look forward to the experience I get to share with other Inuit women, the stories we will hear, the things we will learn. I am grateful to Angela Johnston for making this possible and for her dedication to culture.

Quana!

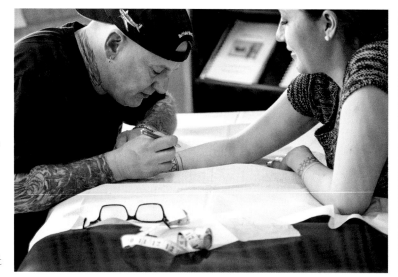

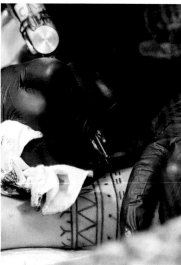

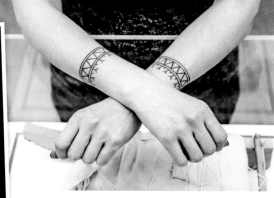

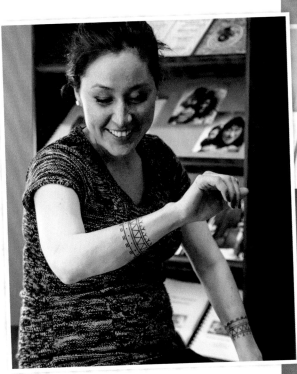

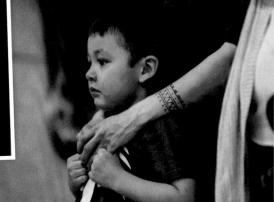

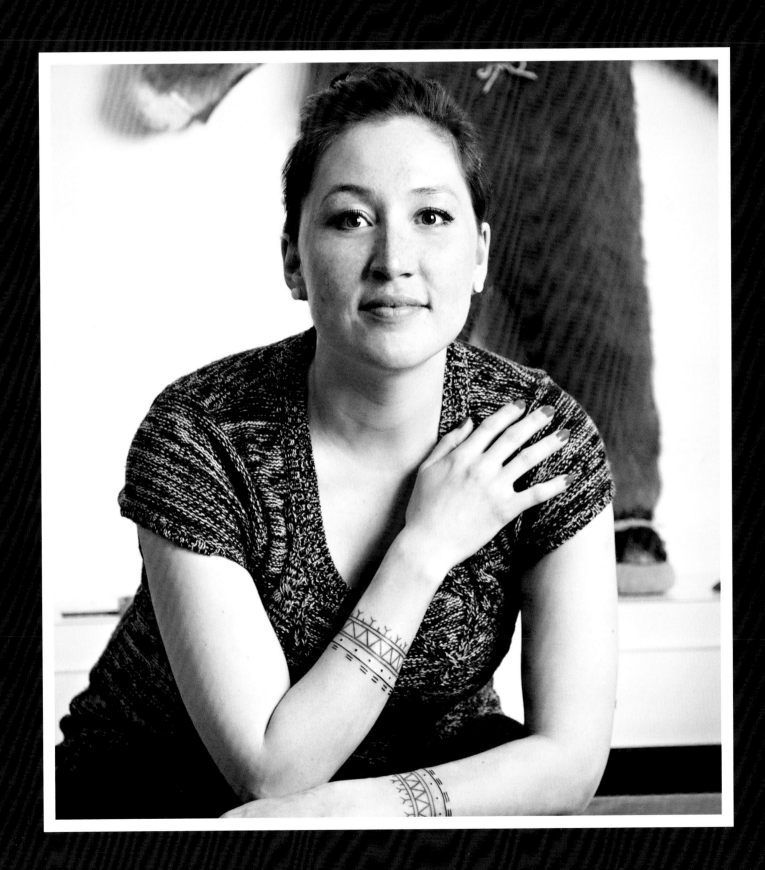

Catherine Niptanatiak

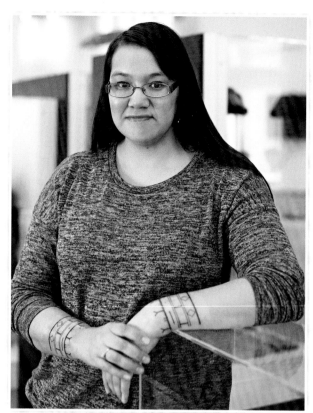

My name is Catherine Niptanatiak. I was raised and live in Kugluktuk, Nunavut. I am thirty-two. I am of Inuit descent.

I feel that it's in my blood and in my spirit to have traditional tattoos. I've always admired how the traditional tattoo made a woman look strong, how it made her even more beautiful and confident, somehow. I liked that it shows she's completely comfortable with who she is and where she comes from.

As I was growing up, I was made fun of for not being full Inuk and having white relatives and for being smart. I shied away from being Inuk, from trying to find out who I am, from fully connecting to my culture. It wasn't until I was older that I realized it shouldn't matter so much what people think of me or what they say to me. I am me; whether people accept me or not is not my problem.

Since then, I've been proud of my culture, proud of where I come from, and proud of who I am.

Before I learned the real reason for a traditional tattoo, I thought of it as a symbol of a woman who has come into her own, who has taken her name and accepted who she is. They are used as a rite of passage and a source of pride. I learned that the tattoos were done at puberty, when a young woman would be tested to see if she could withstand the pain. If she was able to, it meant that she was strong enough to bear children, and she was marked, or tattooed, for others to know. She was tattooed once she was grown enough and could take on the duties of a grown woman. A woman's traditional tattoos meant that she had the skill to raise a family, to care for a husband. Tattoos are also used as spiritual protection, a way of keeping one safe and protected from forces greater than humankind.

I've never really had anyone to teach me about traditional tattoos, nor have I had anyone to talk to about them, but I've always been interested. I've researched online and read books, but I don't feel that it's the same as having someone who knows the meaning and the symbols tell you about them. I didn't know what tattoo design I would get, but I knew I wanted wrist and hand tattoos.

I designed my own, something that represents me and who I am, something that I would be proud to wear and show off, and something that would make me feel confident and beautiful.

I feel that our culture has come too far from our roots and that someday we will forget where we came from and who we are. I'm afraid that we are going to lose everything. This is my way of connecting to my culture, my attempt at keeping some traditions alive.

I've had other tattoos done and I love them. I feel they represent me and tell a story. The traditional tattoos tell who I am. Keeping my culture and these practices alive is important to me, especially because I have daughters and I would like to teach them what I know. I would like for them to want to practise our traditions and keep our culture alive. I want this to inspire them to love who they are and where they came from.

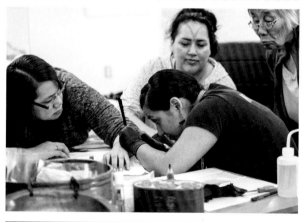

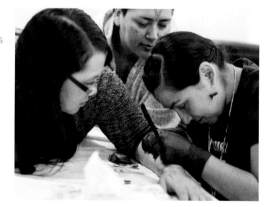

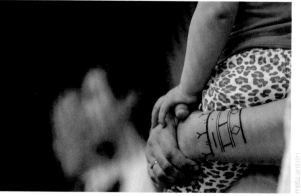

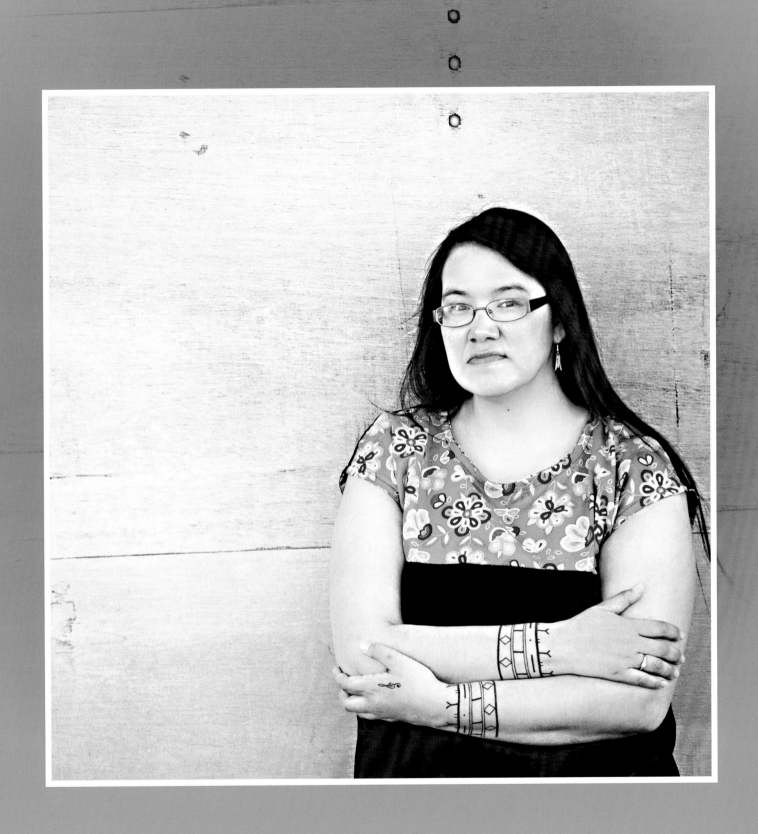

Cecile Nelvana Lyall

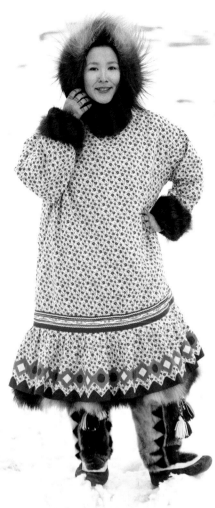

I wanted a mixture of both traditional and contemporary methods of tattooing, blending the two practices and finding a balance between the two worlds. I've wanted to have my hands and thighs done for a while, but needed help with the design and full meaning of each line.

From what I understand, the meaning of thigh tattoos is to show a newborn baby beauty as the first thing they see. I'm not ready for children yet, so I don't feel ready for the thigh tattoos. I would like to have some help to design them when I am ready.

On my hand tattoos, from the top down, the triangles represent mountains, and I chose these because my dad's family is originally from Cape Dorset. They were a part of the relocation from Hudson Bay to this area. The Ys are the tools used when seal hunting. I grew up in the Netsilik region, so this part is like my history. The dots are my ancestors. I wanted these done the traditional way to pay homage to their way of life and create the balance between traditional and contemporary practices.

Being able to receive the tattoos in Kugluktuk, where my mother is originally from, is truly amazing. The last member of her family to be tattooed in the area was, I believe, my great-grandmother. She would have been tattooed about 100 years ago.

I am so excited to be able to truly call myself an Inuk woman.

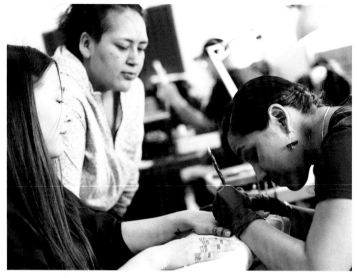

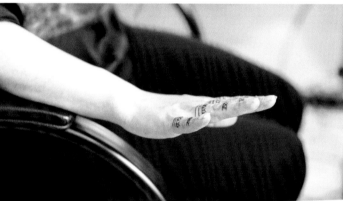

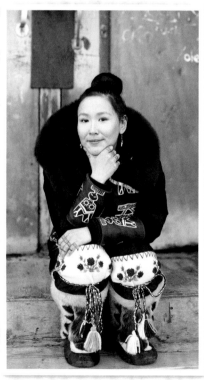

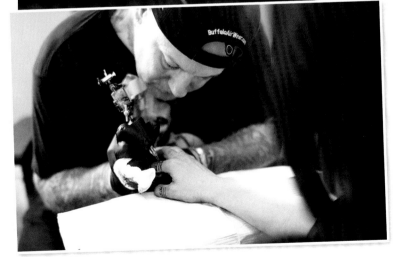

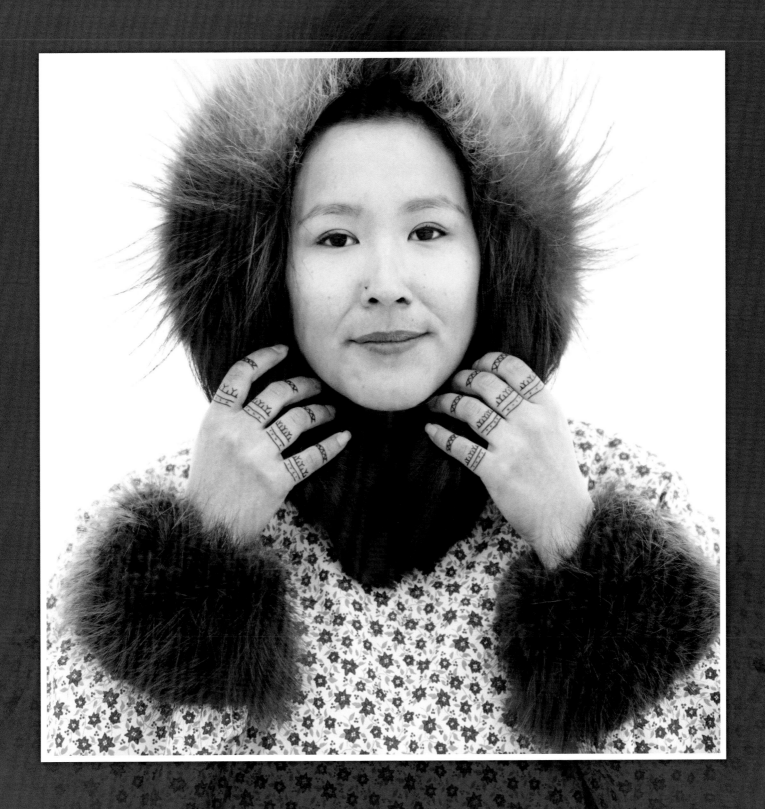

Colleen Nivingalok

The tattoos on my face represent my family and me. The lines on my chin are my four children—my two older boys on the outside protecting my daughters. The lines on my cheeks represent the two boys and the two girls on either side. The one on my forehead represents their father and me. Together, we live for our children.

Getting these tattoos is very important to me because it gives me a sense of identity. I want more now, but made in the traditional ways.

I am proud of who I am and where I come from. #PROUDINUK

Angela created this opportunity for me and many others to express our unique identities. I am grateful.

I can't explain the feeling of pride I have for my facial tattoos. Maybe over time.

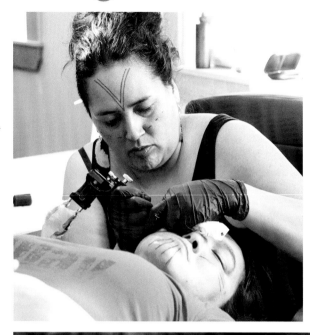

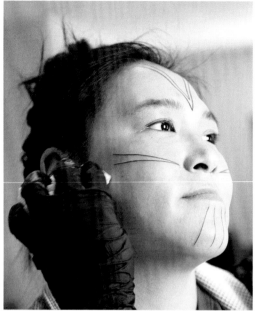

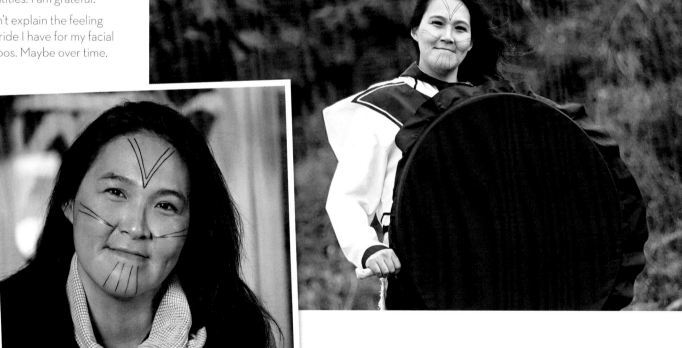

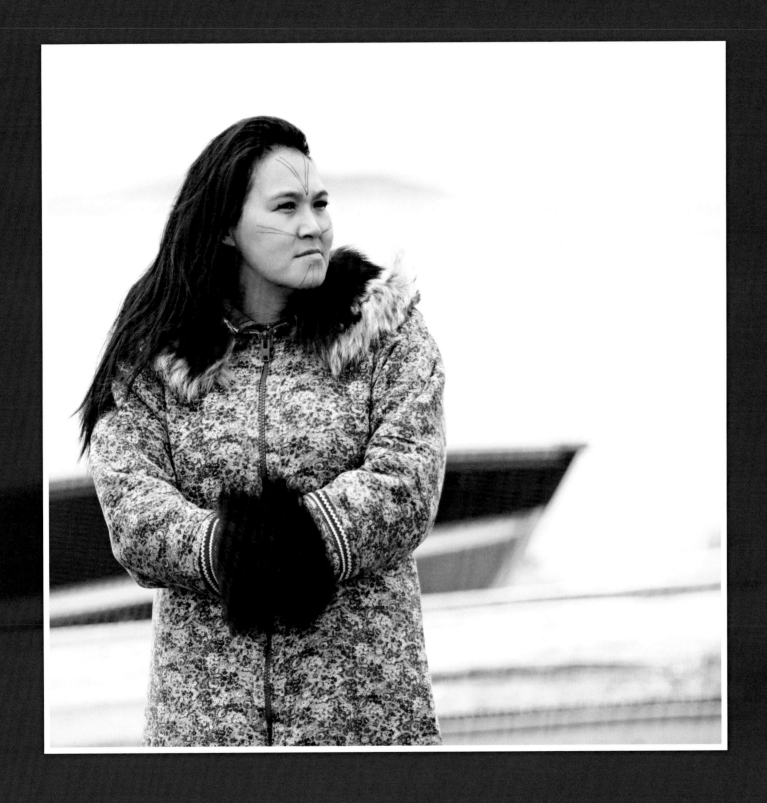

Coral Nattit Westwood

I still have a lot to learn about traditional tattooing. The traditional tattoos symbolize passing through important phases in life. They also symbolize beauty and maturity and hold different meanings because people have different views of their own lives.

I want to know more, as it is important to me to bring back as many of our traditional ways of living as Aboriginal people as I can.

The tattoos are important to me because I want to be more connected to my culture. It will bring me great honour to have them symbolize my life, as they will keep me on my path.

They remind me of my ancestors and how they survived. We have it much easier than they did. The tattoos bring me closer than I ever have been to my traditional way of life—although we all know we can never put our devices down for more than an hour.

But these tattoos are another goal I have achieved in bringing back our ways of living in the North.

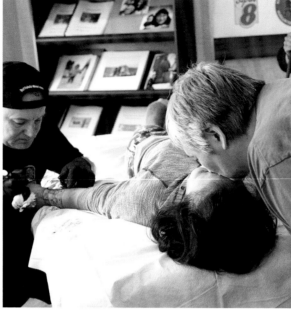

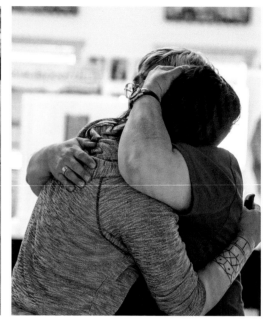

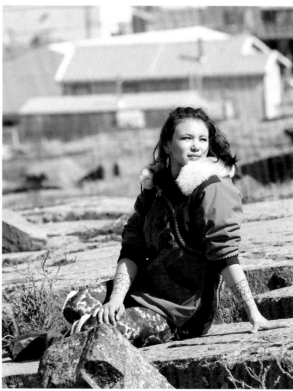

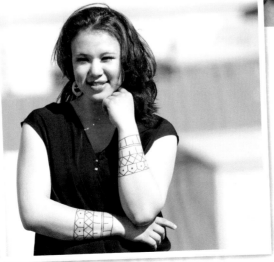

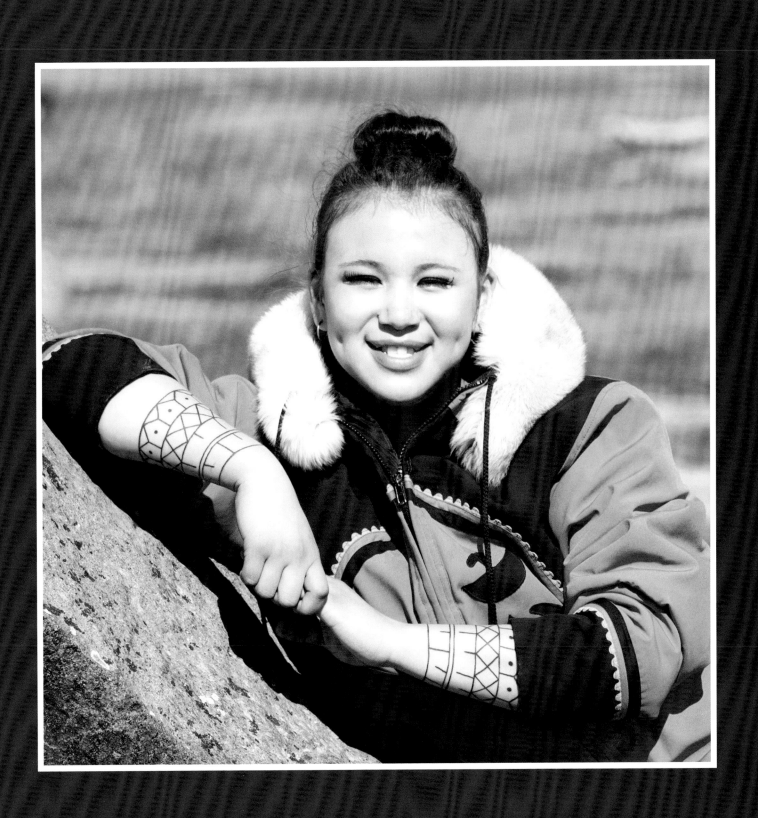

Daisy Nalikak Alonak

It means a great deal for me to get the tattoos. My namesake had them. I was always eager to know as much as I could about her. I feel like it's something I have to do.

When I was about ten years old I asked my mom if I could get the tattoos done. My mom didn't know the stories behind them, so she asked an elder, who said I had to wait until I was older, until I was a woman

I don't know much about the tattoos, but I asked my dad, Adam Kudlak, who I thought might know about them, and he said in our region the V on the forehead was for the *tuulliq* (loon) and the Y was for wind protection when the guys were out harpooning *nattiq* (seals). I've also heard that the ladies got tattoos to look beautiful, or when they were bored while the men were out hunting.

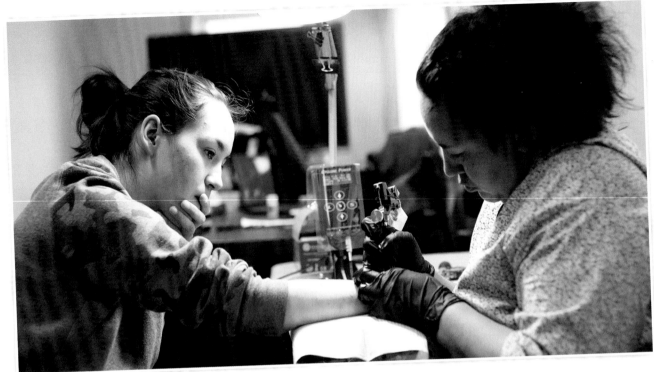

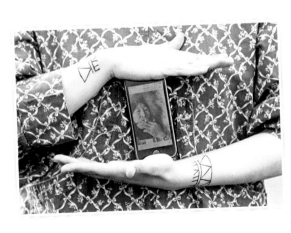

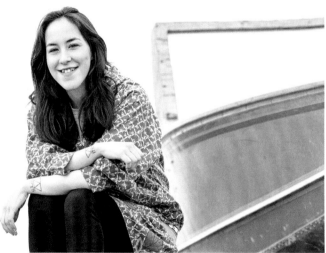

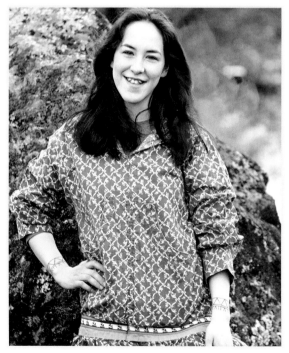

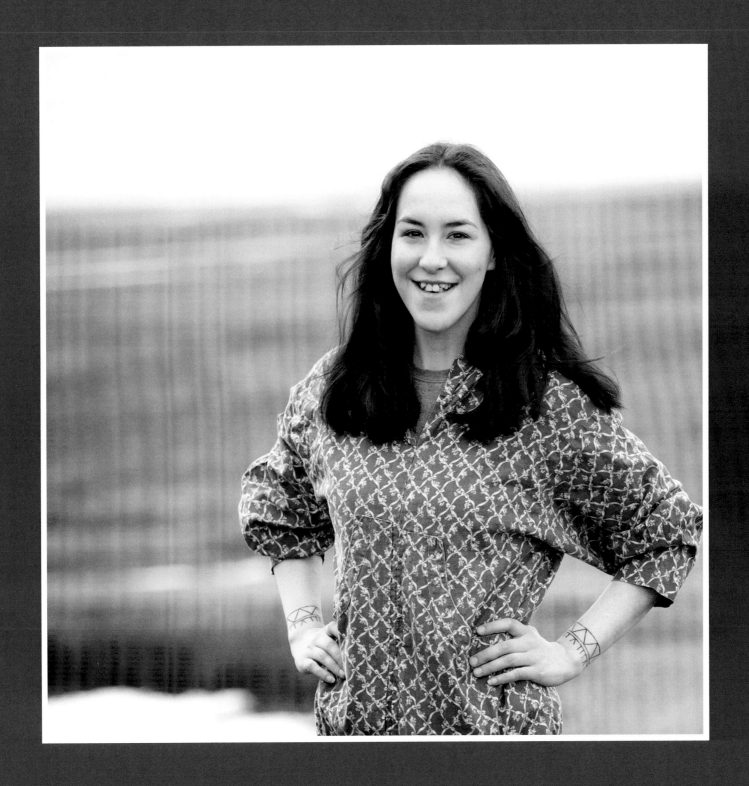

Doreen Ayalikyoak Evyagotailak

I have thought about getting traditional tattoos since I was a teenager.

When I was a little girl I saw some elders with tattoos on their faces, wrists, and arms. I didn't know the meaning behind the tattoos until I spoke to a few of them.

The elders said traditional tattoos were used to look nice, as they didn't have makeup back in their day. One elder told me the tattoos aren't what people think they are about, such as kids, family, and so on. Women were tattooed for beauty.

When I asked the elders if I could have my own meaning for my tattoos, they said it wouldn't matter.

My tattoos symbolize my kids.

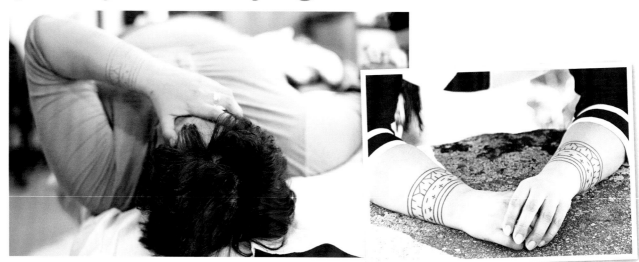

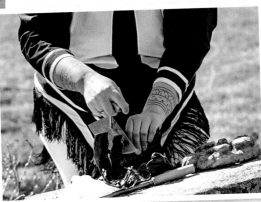

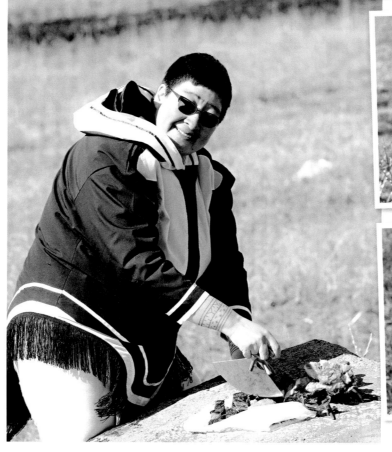

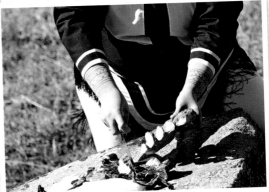

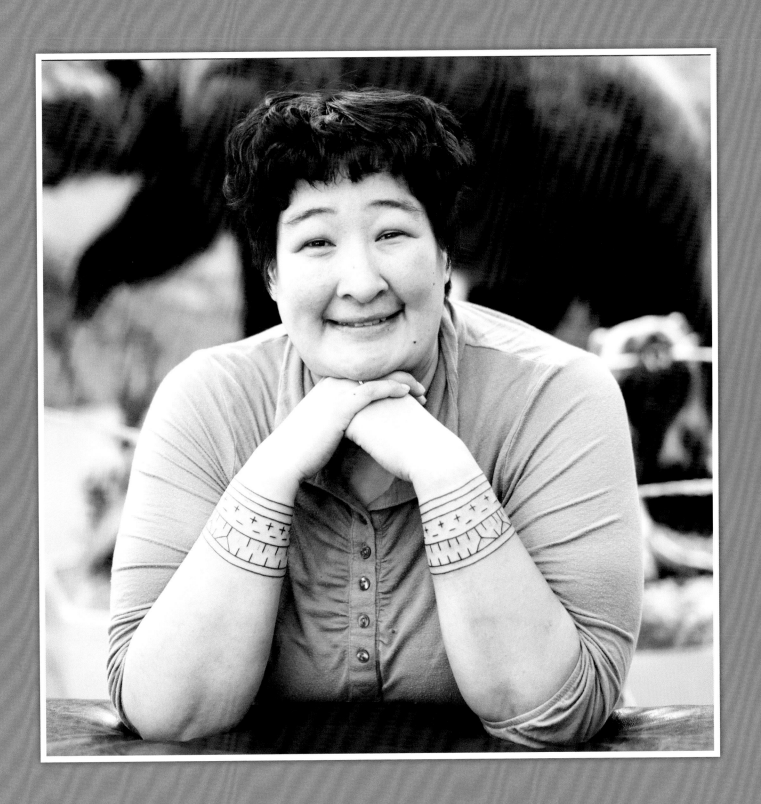

Jaime Dawn Kanagana Kudlak

My late great-great-grandmother, Helena Kalvak, was one of the last known Inuit women to have been traditionally tattooed. She had this tattoo. My traditional tattoo comes from People of the Large Bay, so some think that it represents where we came from.

So far my aunty Emily Kudlak is the only Copper Inuk with one.

Having this tattoo makes me feel a deeper connection with my Inuit culture. My aunty Emily is the second person so far to get this tattoo. She and I are very close. Since I got this tattoo, I can feel our connection is much stronger.

You don't see many Inuit tattooists. I thought it was cool to be tattooed by Hovak, an Inuk woman who has her own tattoos. I got to understand the meaning more through her.

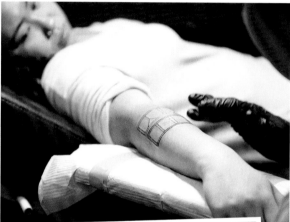

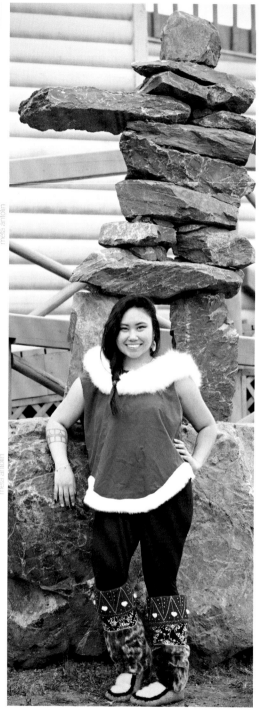

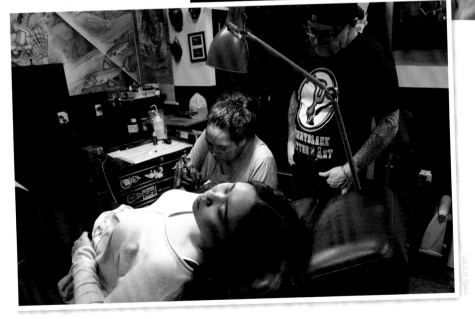

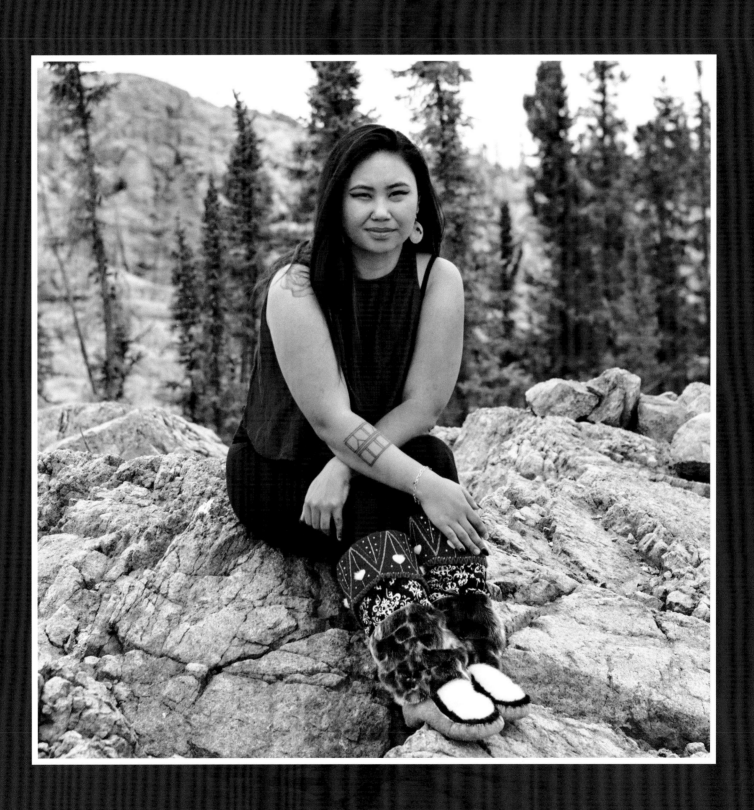

Janelle Angulalik

My traditional tattoos mean a lot to me because they represent my granny, my dad, and my grandpa.

They are the most important people to me, even though I didn't meet my late grandparents, and my dad has passed away. I miss him so much. I feel a little lighter knowing they'll always be with me to guide me on which path to take and to help keep me thinking positively.

I know about traditional tattoos, and having them keeps the tradition alive.

Since I got my tattoo people say I look like my granny and my dad.

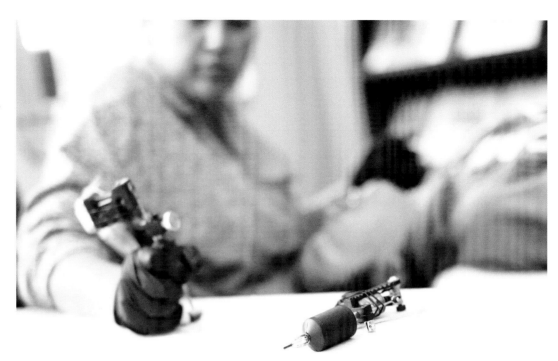

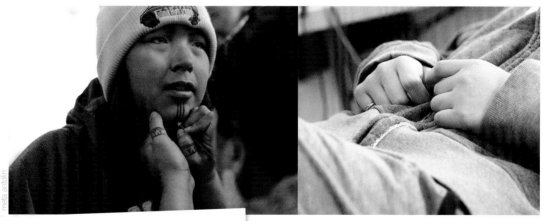

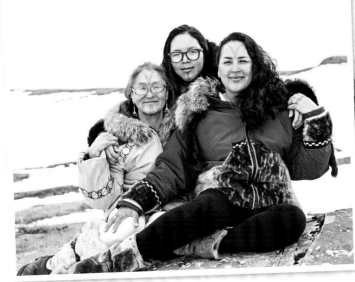

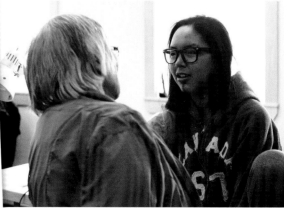

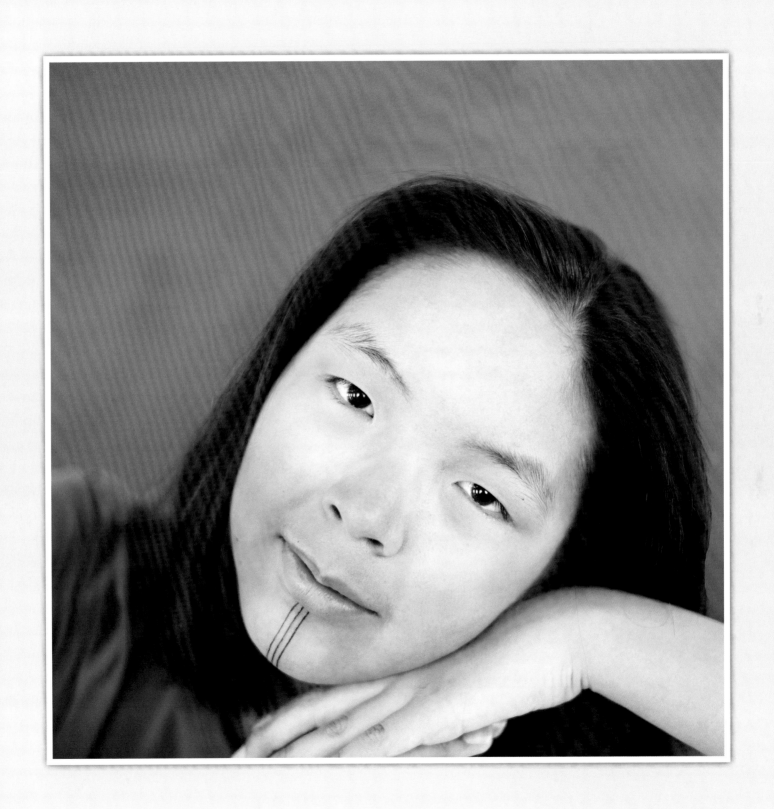

Kanayok Klengenberg

The tattoos I have on my thighs represent my culture and family. The Ys facing down represent my first-born baby boy. It is important to me that I have this design on my thighs, because whenever I travel away from family for medical reasons or work, they are with me in spirit. The zigzags under my Ys represent the hills, mountains, and barren land where I'm from—Kugluktuk, Nunavut. They're important to me because we spend most of our time at the cabin (if we're not working), hunting caribou, picking berries, plucking ducks and geese, and gutting fish.

I have lived in Yellowknife for the past sixteen years, but I am so eager to learn more about my culture and ancestors. I want to know how they managed out on the land for months on end, finding ways to survive our long winter months and finding ways to cross waters.

I know that traditional Inuit tattoos were given to women who were ready to become adults as a rite of passage, with certain meanings and symbols given by an elder.

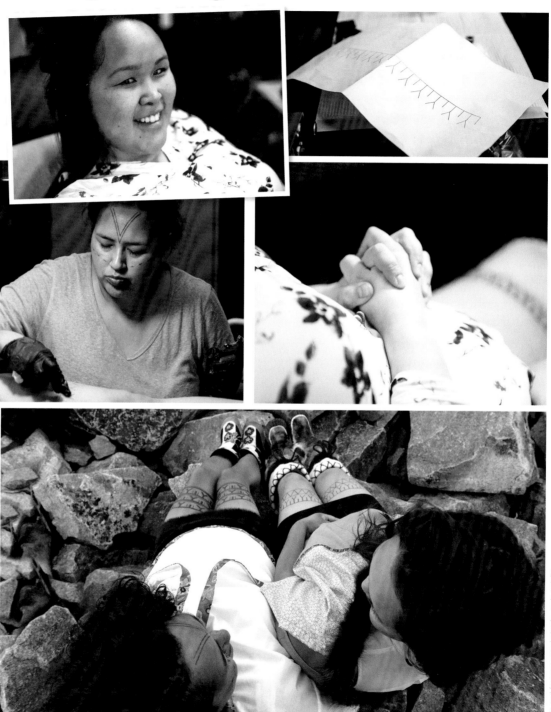

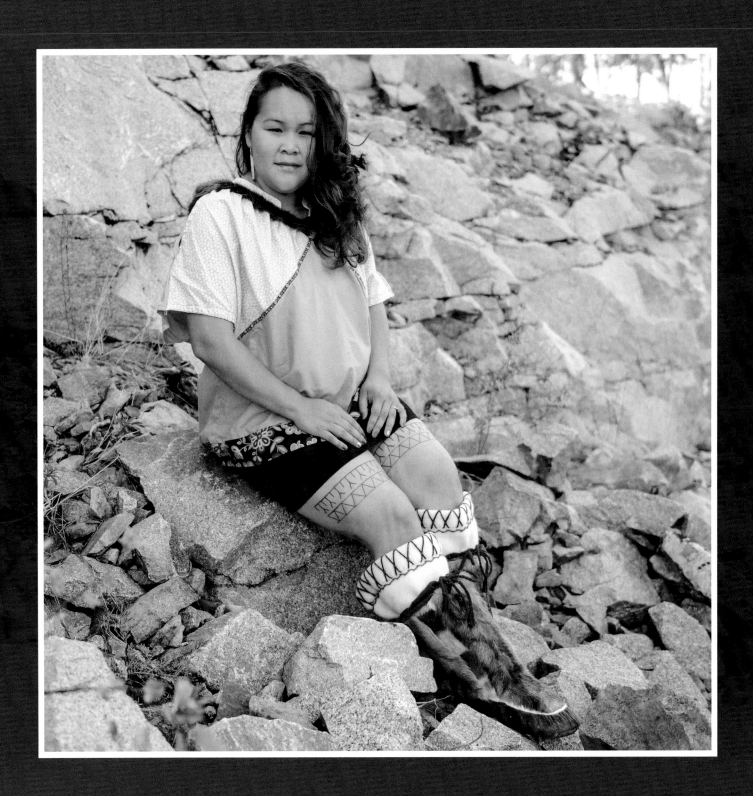

Kaoktok Algona

My tattoo markings represent the four most important women in my life: May Ohokmik, Agnes Kavgak, Mary Hogaluk, and my great-grandmother, Betty Ototak.

I remember seeing my great-grandmother when I was four or five years old. She had tattoos on her wrist and her fingers; I always thought she looked so beautiful. I will replicate her tattoo markings eventually, when I'm ready. My V is in honour of her.

Having the tattoos gives me confidence and makes me feel like the true Inuk that I am.

I am very thankful, proud, and happy to be part of Hovak's bringing Inuit tattooing back.

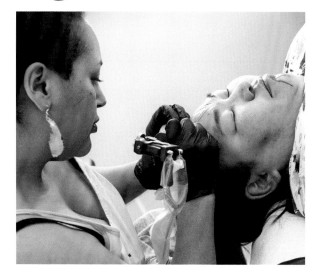

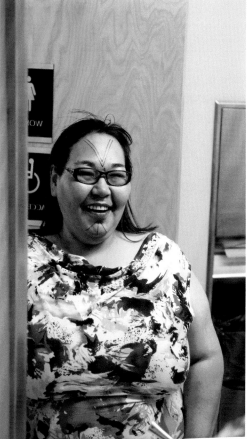

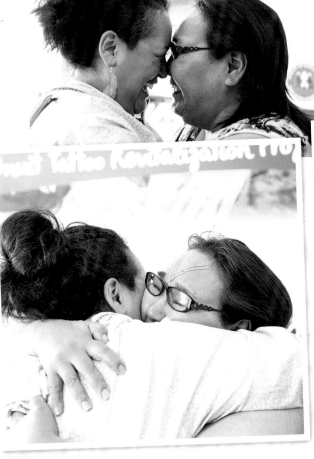

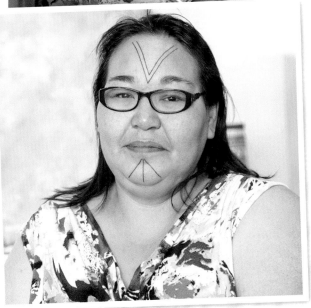

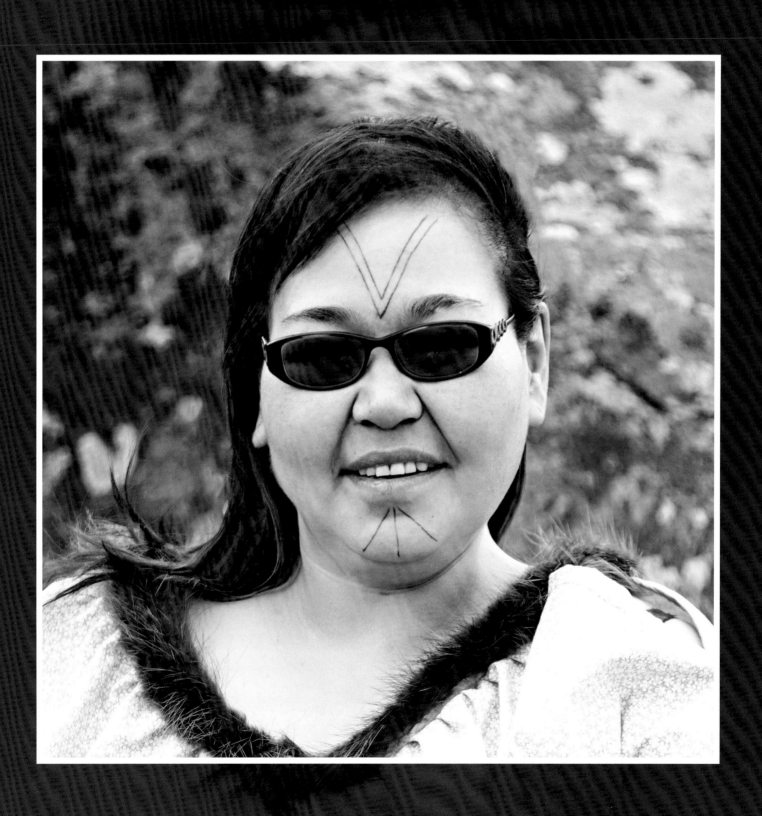

Mary Angele Taletok

I always wanted traditional tattoos like the women in the old days. I wanted them on my wrists and my fingers so I could show I'm Inuk. They look neat and are beautiful. From what I saw and heard about them, I wanted the *tunniit*, the tattoos.

I asked my dad about tattoos and he told me women liked to have tattoos to look beautiful. Sometimes when there was nothing to do they would make tattoos. My dad also told me different tattoos on different parts of the body had stories behind them.

Having traditional tattoos is a part of my culture, which I want to keep alive. By having the tattoos, I can show them to other Inuit.

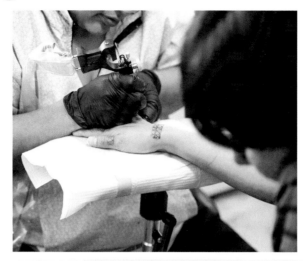

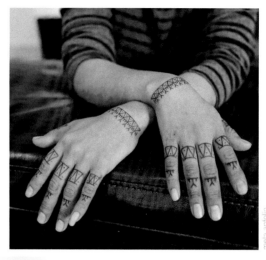

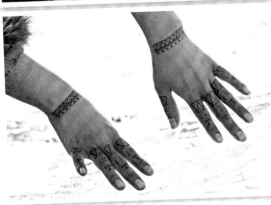

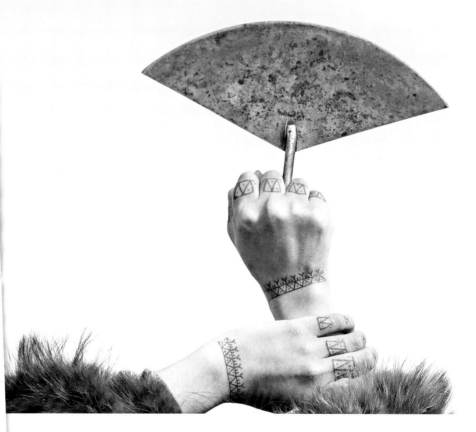

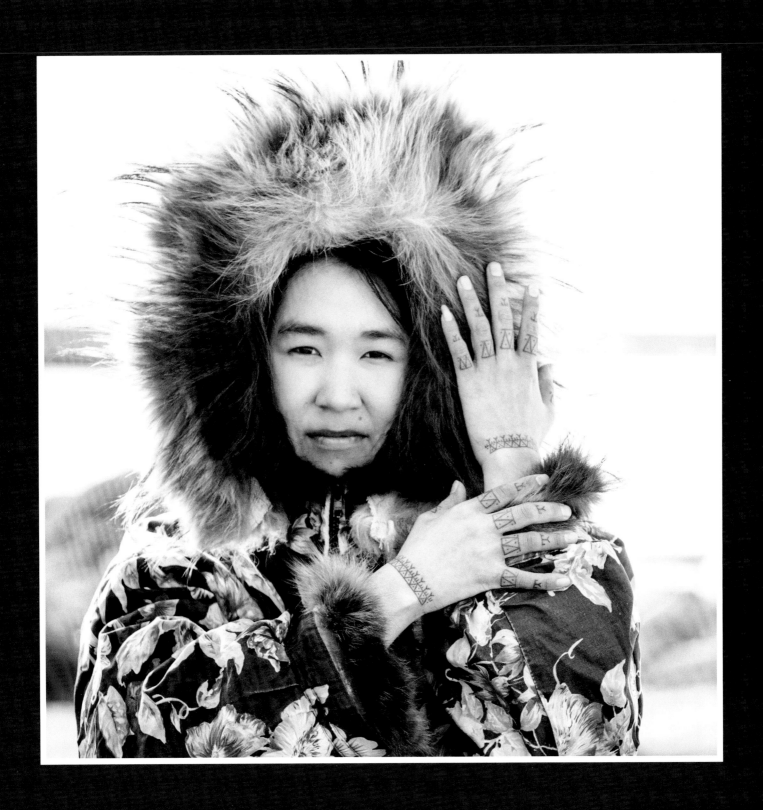

Mary Ann Kilak Niptanatiak Westwood

While growing up I used to look at the grandmothers' tattoos on their hands and faces and think that they were so nice, neat, and awesome. I thought that when I grew up I would get some like theirs. I wanted to get some on my hands, but at the same time, was not sure. I know there are different meanings to the tattoos for each person, but I do not know what they are; I never asked.

By getting my hands tattooed I can continue with some of our traditions and also have what the grandmothers had.

I think the tattoos are beautiful. I would like to think that other women and young ladies of our culture also find the face and hand tattoos beautiful and give meaning to them and our tradition.

My tattoos represent my mother and grandmothers. The little lines at the bottom represent my children and grandchildren.

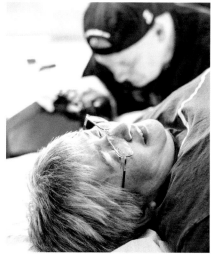

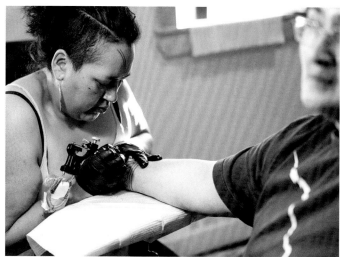

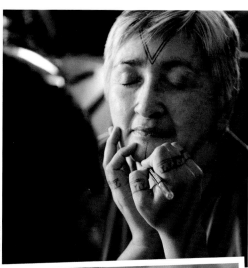

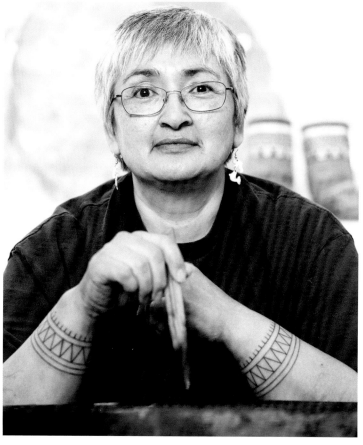

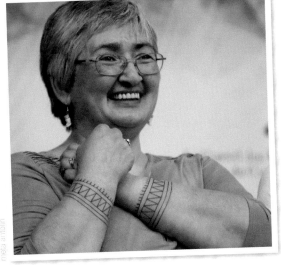

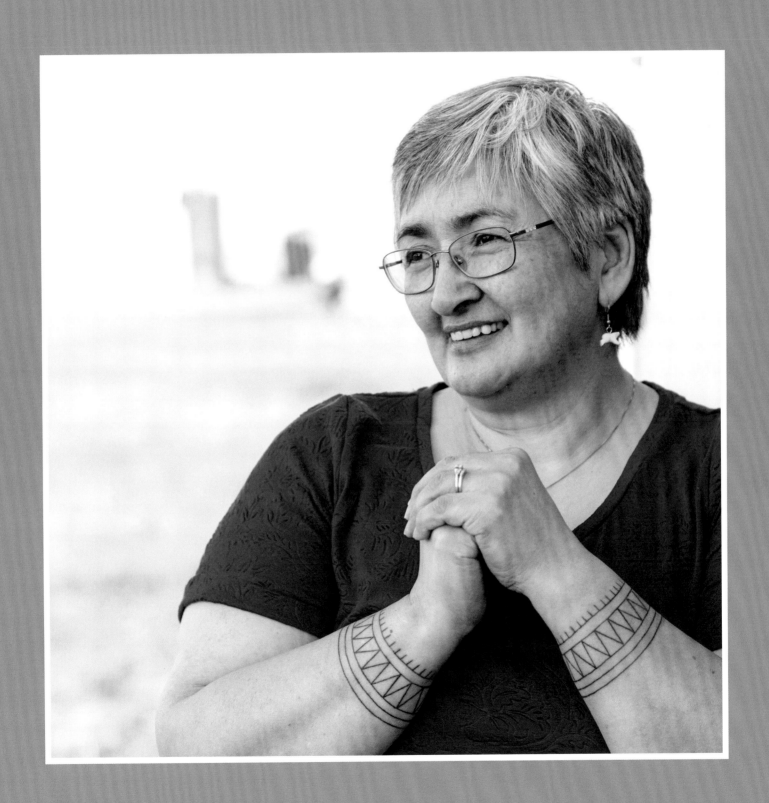

Matilda Panioyak

I wanted to get tattoos because I thought of a cute little old lady—Nalikak was her name. I was so fascinated with her facial and hand tattoos, and I used to wonder how she did them and how long it took her to do that.

So I told myself that if I ever got tattoos, I would want them like hers, excluding the facial ones.

I asked my common-law spouse how he felt about it, and he said it's up to me. And yup, it is.

So there was that lady who made me want to get tattoos.

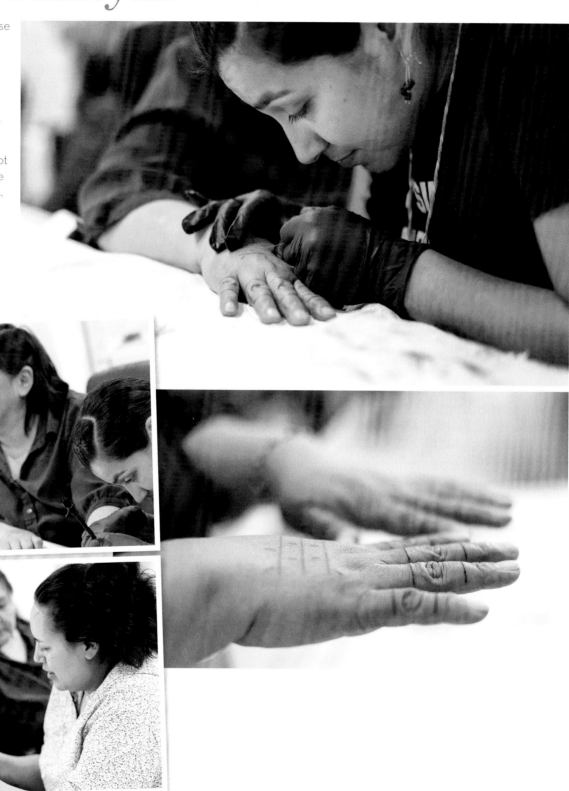

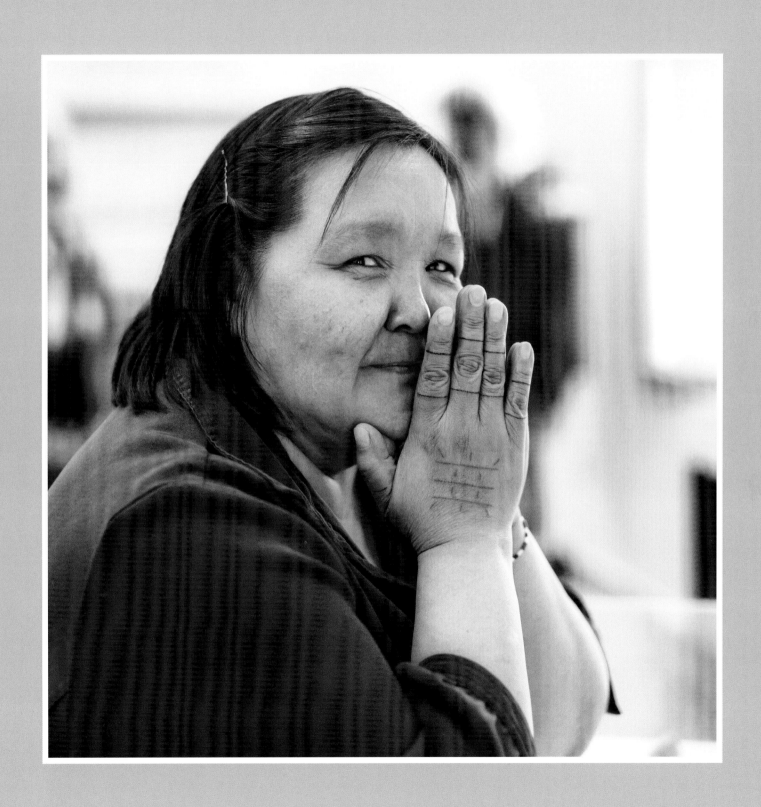

Melissa MacDonald Hinanik

For quite some time I knew I wanted the tattoos, but felt they had to be done with people I know and trust. The practice of traditional tattooing is a really intimate experience to me, which I am sure our ancestors felt, too. I am sure they felt it had to be done by someone they knew, someone they trusted. To be able to share this experience among friends here in my home community is the perfect opportunity to finally receive my tattoos.

What I know about the traditional tattoo is that it was done to show that a woman was prepared for womanhood and all the responsibilities associated with the coming of age. It was also an expressive form of art that, like many of our traditional practices, shows the connection our people had with their environment. This came to an end after contact with the white man and the missionaries. The art of tattooing was banned for religious reasons and fell into disuse for decades.

For me and many others, the traditional tattoo is a beautiful form of expressive art which should have the same importance to our people as our songs, throat songs, stories, and performing arts do in our unique culture.

As a part of celebrating my heritage and revitalizing important traditional customs that form my identity, I believe I have earned the tattoos. I am a beautiful, strong young woman. I am a mother, a wife, a daughter, a friend, and an active community member. I reclaim the traditional customs as mine, I re-own them as a part of who I am.

By receiving my tattoos, I am understanding my past in the present to plan for the future with my family, with our heritage, culture, and language.

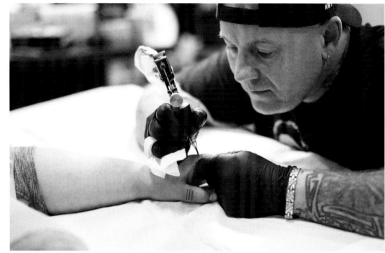
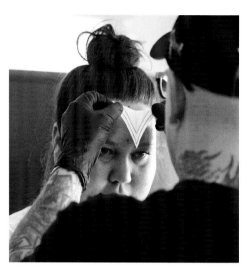
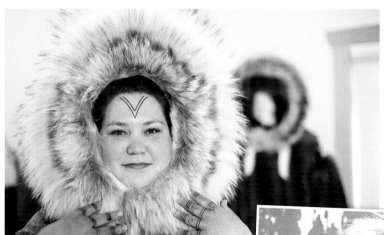
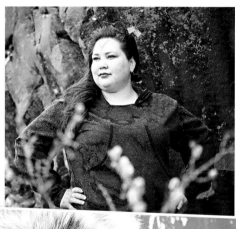
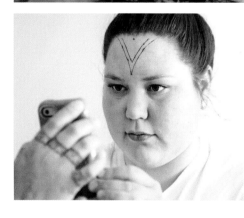
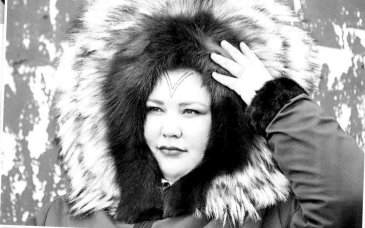

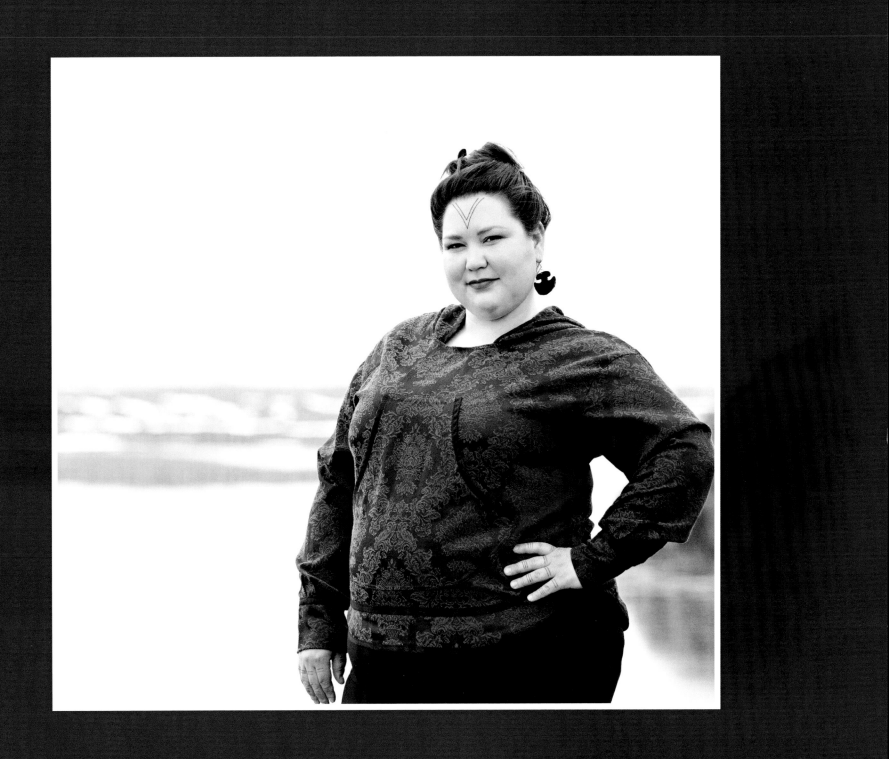

Millie Navalik Angulalik

The lines on my forehead represent my parents, Bessie and Luke; the five lines on my chin represent my niece Patricia, two sisters, Martha and Gwen, and my parents. The two lines that have been stitched on my arm represent my two brothers, Robert and Norman. All have passed away.

I'll always feel my mom and dad here; they're the centre of me. They'll be with me forever to guide me through the Inuk way of life.

This is so powerful and I'm so blessed my niece Angela Hovak Johnston did my tattoos—I really thank her! The tattoo design on my forehead is a replica of her facial tattoo.

I've always been Inuk, but now, after getting these markings, I feel like a real Inuk. I love it. I'm so proud of myself for doing this. I know I'm going to be strong now to walk forward in life.

This was the best meaning of my life.

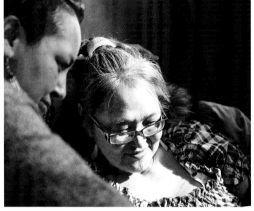
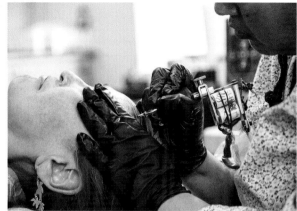
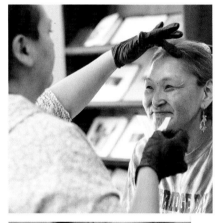
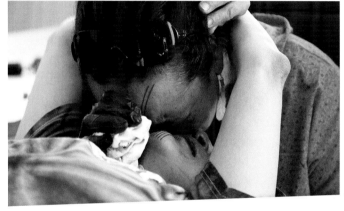
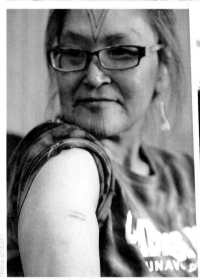
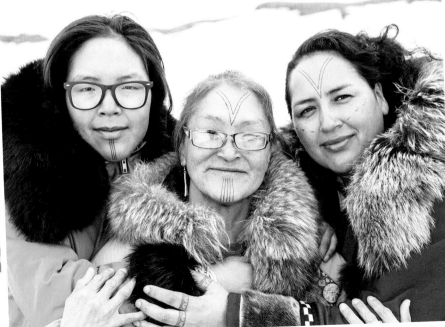

meta antolin

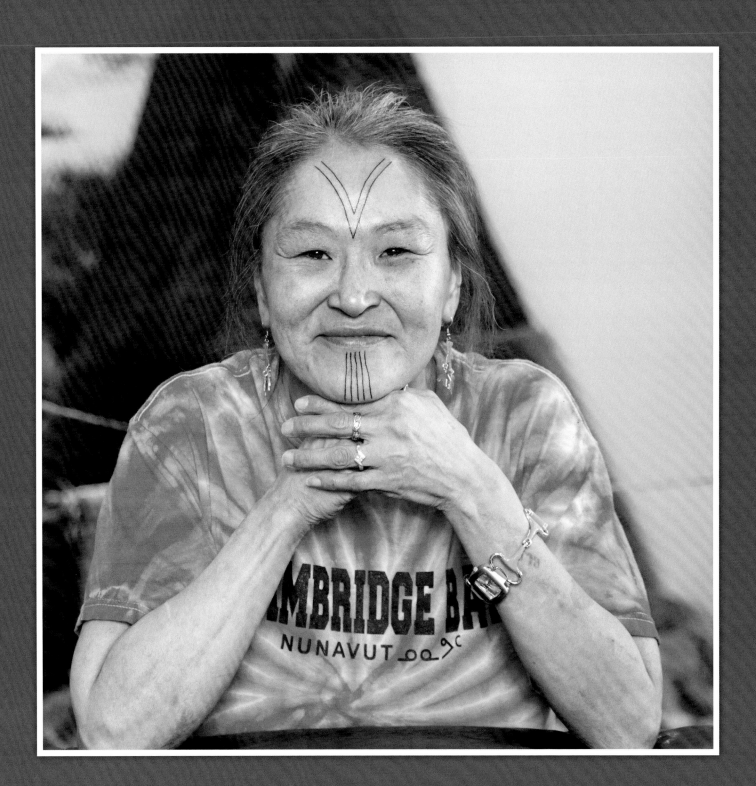

Miranda Kopot Atatahak

My tattoos are done to honour my *anaanattiaq* (grandmother), Bessy Kudlak Taptuna.

I have a vivid and beautiful memory of her hunched over her sewing. I remember she used to chew Big Red cinnamon-flavoured gum and always had a warm cup of tea. She wore satin dresses.

When I was a child she made me a beautiful *hikhigalik* (ground squirrel skin) parka. I remember sitting beside her as she carefully stitched each piece of skin together. She smelled like cinnamon and Red Rose tea and I held on to the hem of her dress. My inspiration for my tattoos comes from this memory and has been incorporated into my design. With these tattoos, I recognize the importance of being interconnected.

My strength stems from my connections with the past, the present, and the future. These tattoos symbolize resilience.

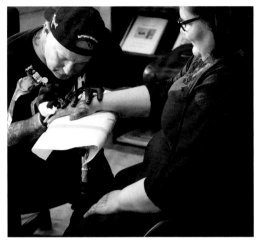

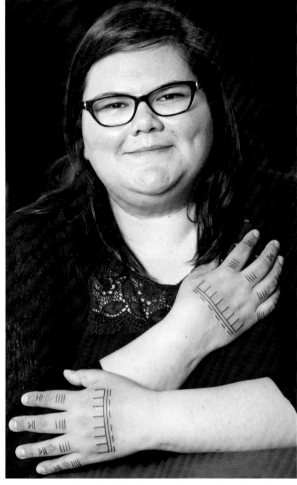

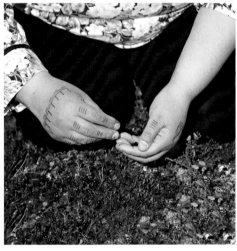

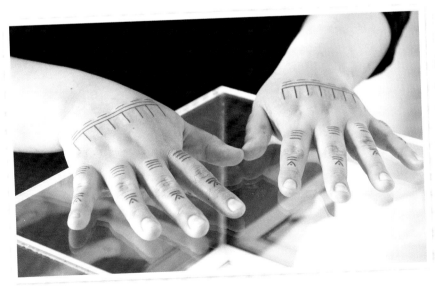

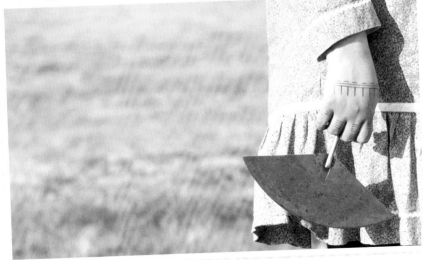

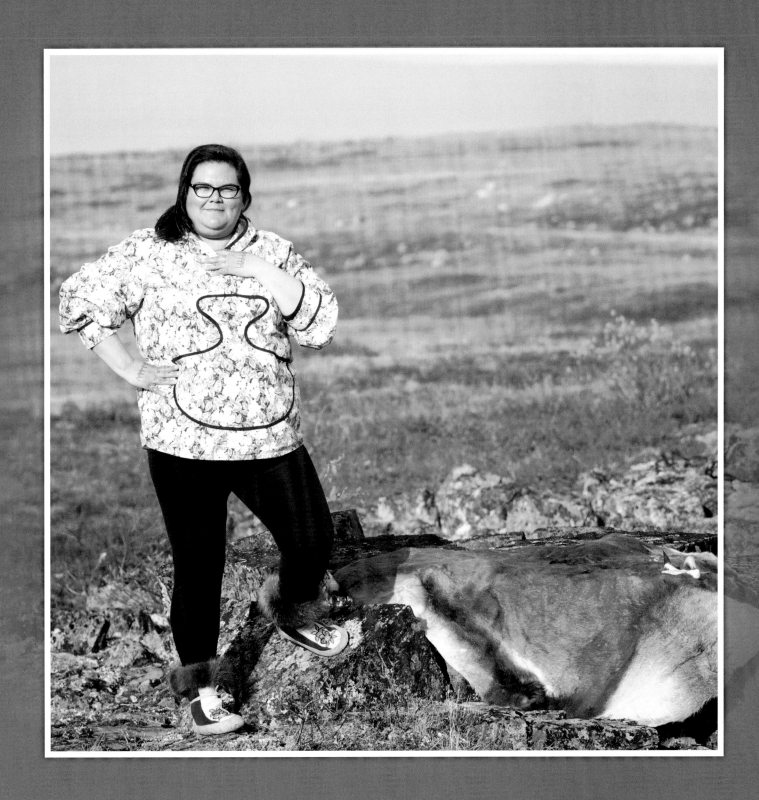

Nancy Nanegoak Kadlun

My tattoo symbols don't have meanings. I know other women, and also women in other communities, have their own different meanings for their tattoos; my tattoos are my makeup, for beauty.

I always wanted tattoos. I used to see elderly Inuit ladies with tattoos long ago. I didn't realize they got them at a young age because I had only seen old women with them.

I wanted an elder to tattoo me when I got my first grandson fifteen years ago, but they didn't know how. It was late Elders Kanovak and Uqhurmik whom I asked to tattoo me. The ladies didn't want to because they thought it was going to be sore, and I told them we have Tylenol and other painkillers, but they didn't want to risk it.

When I finally got them done during this project, it was good. It wasn't as painful as I thought it would be. Marjorie Tahbone from Alaska was very gentle and did a good job tattooing.

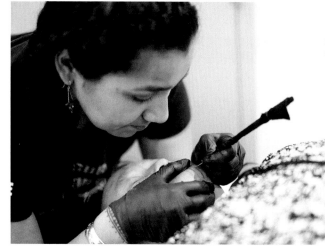

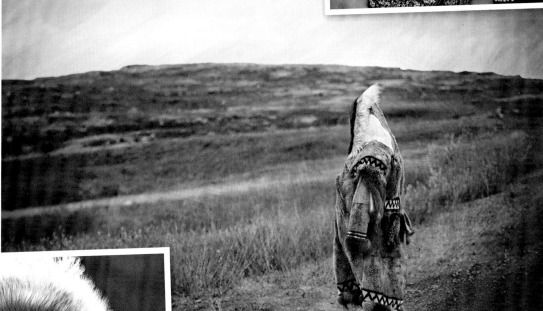

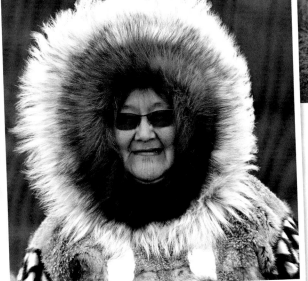

Our ancestors made clothing with animal fur and hides. The clothing was high quality, beautiful, and extremely effective for warmth. Women hand sewed each piece with a lot of thought, patience, and care.

The hikhigalik is one style of women's winter *atigi* (parka) made of *hikhik* (ground squirrel) skins. The trim was usually made with dark and light caribou skins for intricate designs. (Some trim designs are now made with different sealskins.) Parkas could have long strips of wolverine fur stitched on the chest, back, and sleeves.

The sunburst fur ruffs around the hood were made with wolfskin pieces (outer ruff) and wolverine fur (inner trim close to face) for protection from snow and wind.

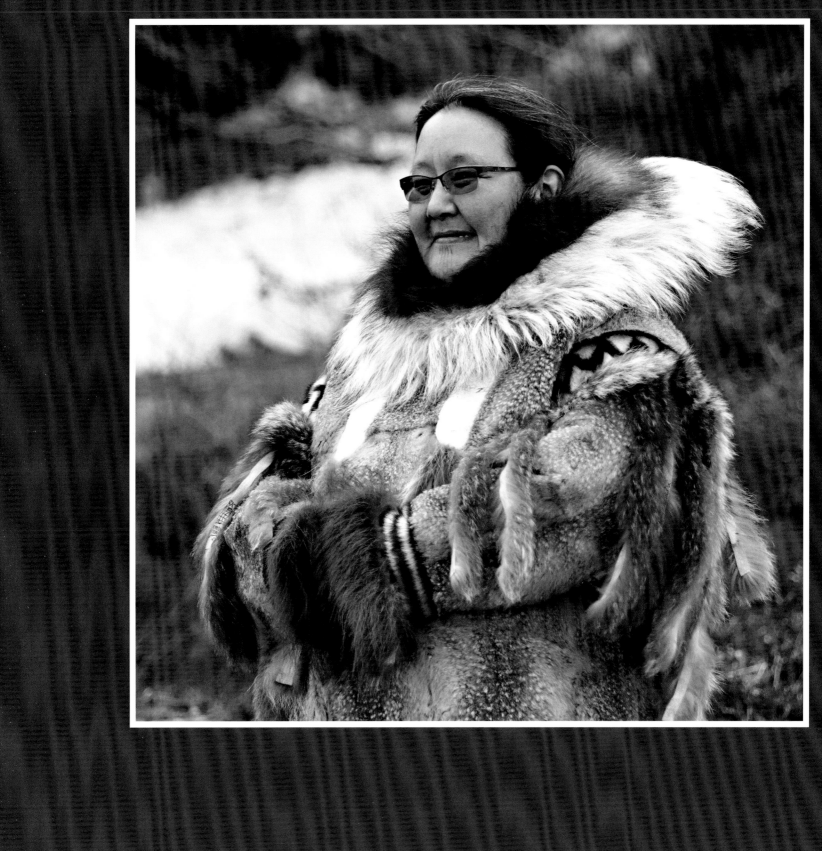

Pitikhi

I have wanted to get tattoos since I was a young girl. I am fortunate that I grew up in Umingmaktok, where there were around sixty people. And I am saddened that my children do not get to witness a way of life that I grew up in.

Tattoos are universal and there are many cultures that have them. They can mean many different things to the many groups of Inuit. When I got the first lines tattooed, I felt like wings were surrounding me and lifting me up.

When Christianity came to our part of the world, they said tattoos were evil, and a lot of people abandoned and lost that part of Inuk identity.

I want to show my identity and be a role model for younger Inuit to be proud of their identity.

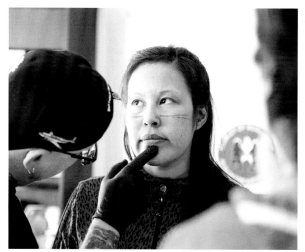

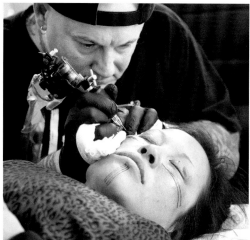

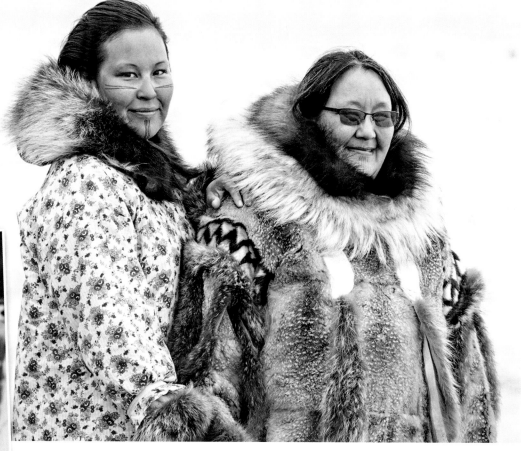

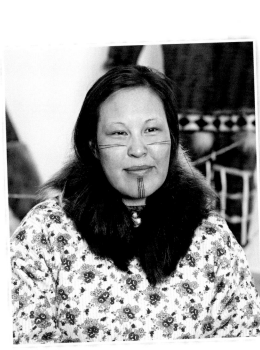

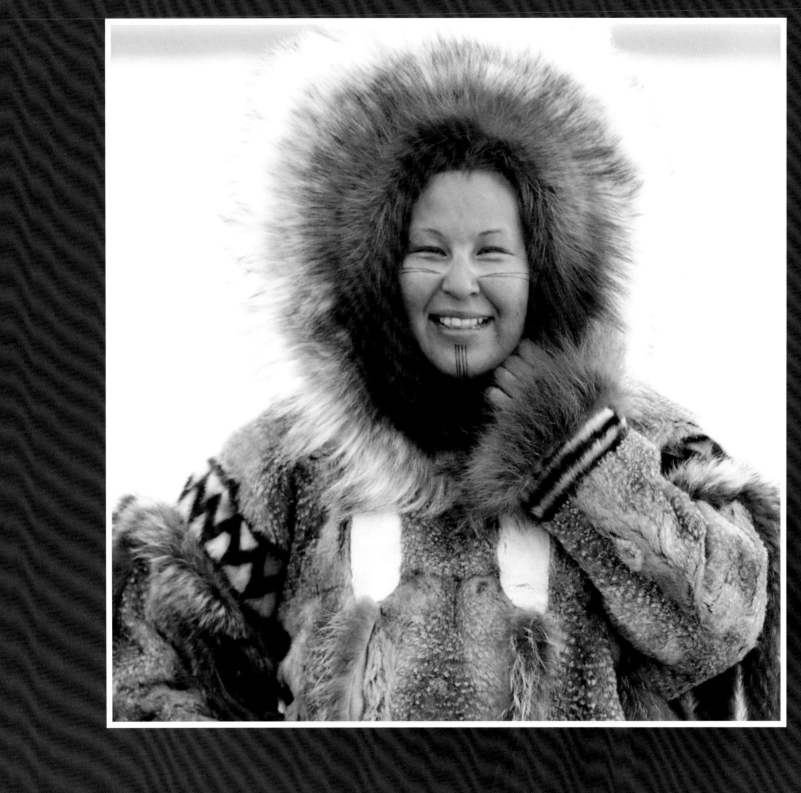

Star Westwood

I don't really know much about the traditional tattoos, but when I grow up I hope I will know everything about them. They are unique and artistic in their own way, and I like how people create the meanings for their own tattoos.

I had been writing on my skin a lot because I wanted a tattoo. I love how awesome they look. I love seeing everybody who has them. And having my own means the world to me.

We still have some of our culture, but some things are slowly dying. Having the tattoos helps us keep our culture alive.

I wanted to get the tattoo to keep my culture alive. My tattoos represent my dad and my dad's dad. The ones closer to my wrists represent my sisters.

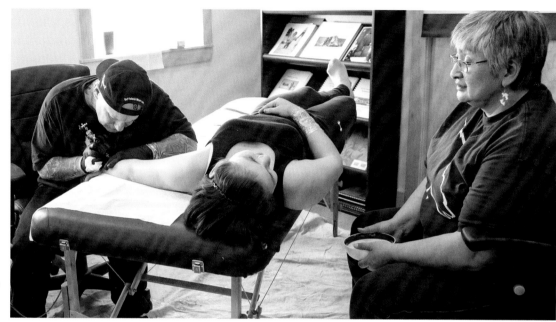

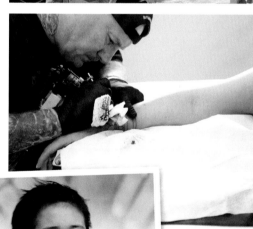

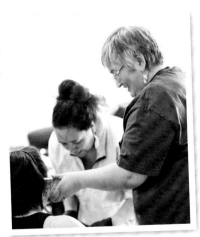

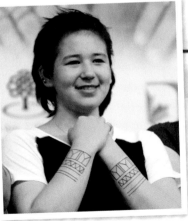

meta antolin

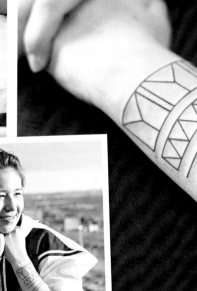

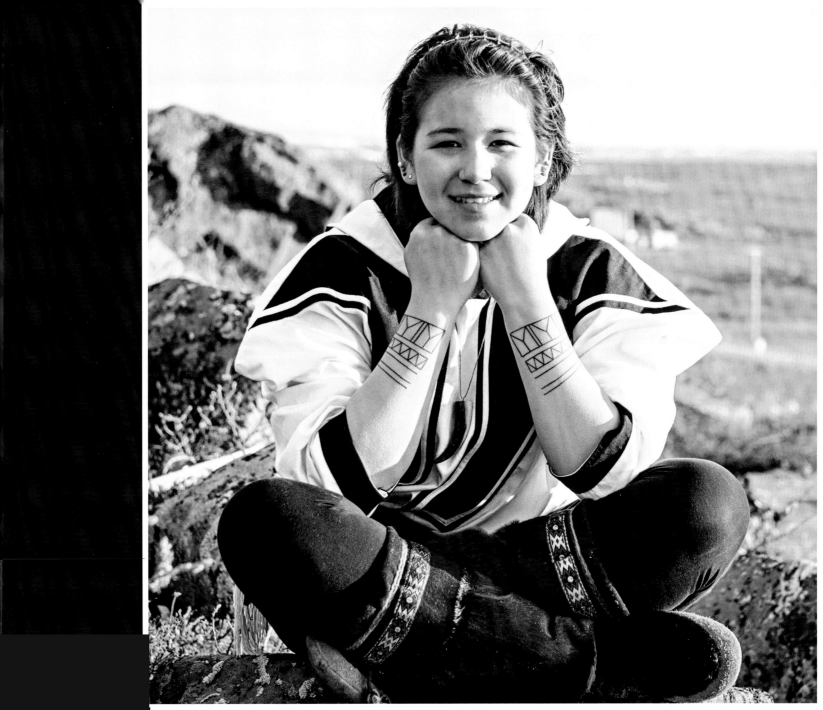

Tanya Kavrak Adjukak Ongahak

I've learned that Inuit women got their tattoos once they'd gone through puberty.

The Inuit tattoos show who they are and are a symbol of what and who is important to them. I also learned they were important for women, because during childbirth, their babies were born into the world seeing the beautiful tattoos! They also showed the beauty of a woman's features and made them feel beautiful.

I don't know much about traditional tattoos, but I do know they are an important part of Inuit life. I've learned they showed where someone came from and who the person was as an individual. They are symbols of who and what was important for our culture, our traditions, and our existence—a major part of our Inuit identity.

I'm very interested in the facial tattoos, because it's such a creative way to bring out the beauty in women. To bring out the importance of who we are, who we love, and everything that matters to us. It is fascinating to take all of that and create these tattoos and have them on our faces.

The details on my face are important to me because each line shows who I am, who is important to me, including loved ones who have passed. They represent the hardships I've gone through that have had such big effects on my life, helped me to learn and become the person I am today. They are a symbol of my family, especially both my mothers, who are so important to me, for keeping us strong and connected. They connect the person I am growing into and the world that's developing around me. Tattooed into my skin and permanent. Something created by everything in my life—both the good and the bad—that creates my whole identity, shapes my life and who I am as a person.

They're a symbol of who I am and who I want to become: a very smart, strong woman with a strong culture and traditional knowledge and skills.

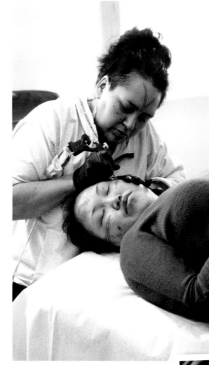

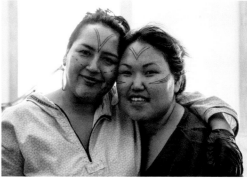

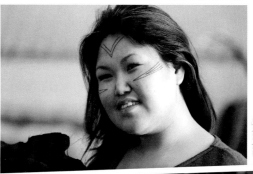

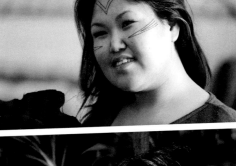

meta antolin

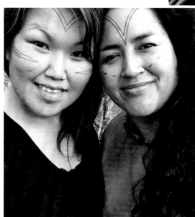

Selfie by Tanya.

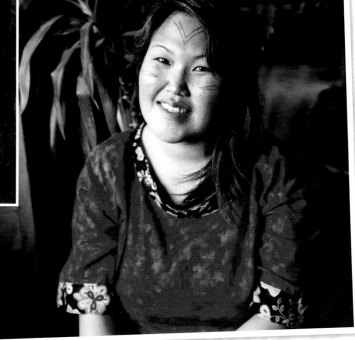

meta antolin

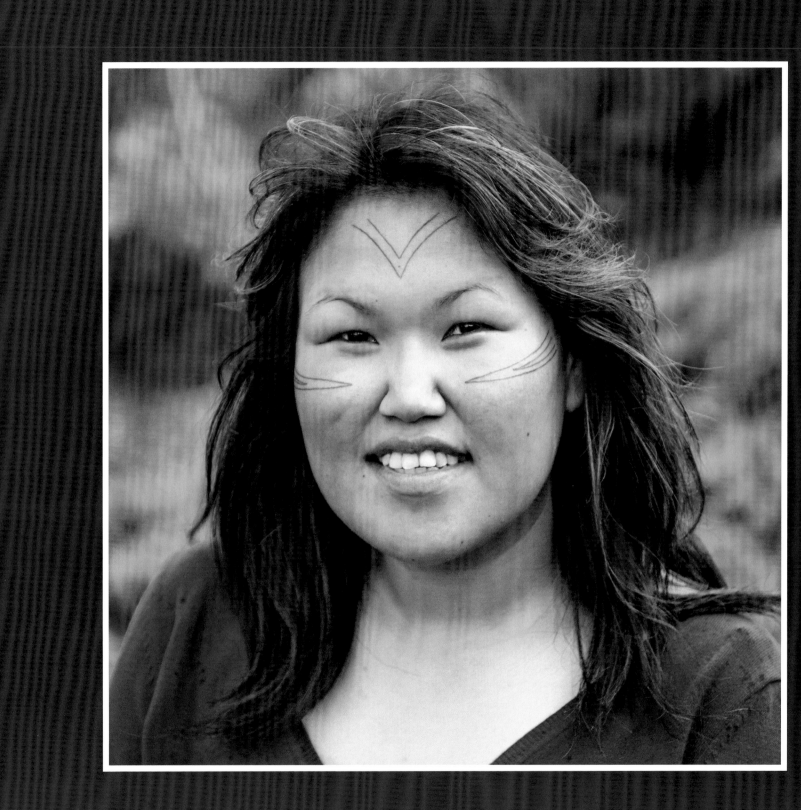

Theresa Papak Adamache

I have been interested in traditional Inuit tattoos since I was a young girl. I've never known anyone in my family to have them—or maybe I was too young to recall. I've always wanted to have my hands and arms tattooed.

Receiving traditional Inuit tattoos is important to me as a preservation of our culture and the markings carried by and passed on from our ancestors. If we do not continue the tradition, it may be lost forever.

I've always embraced my culture through song and dance, though not as often as I would like to. Having the tattoos is my permanent symbol of who I am, where I come from, and where my heart will always be: with our people.

I know some tattoos were a symbol of a good woman to marry. They were also used for beautification. My mother-in-law Helen's grandmother, Kengnektak, had traditional tattoos. She had the double V on her forehead for beautification and three lines on her chin representing her three children, Lily Angnahiak, Kate Nigaktalik Kuliktana, and Tolik (who died at birth).

My mother-in-law suggested that I tattoo my wrist and create my own meanings, so my tattoos signify my husband, my three children, the two children that I lost, my sisters, my parents, and my grandparents.

The six triangles at the top of the tattoo represent my parents and grandparents, the four Ys represent my sisters, the three II lines represent my living children, and the two dash lines represent the two that I lost.

The final set at my wrists represents my husband; the dots in the middle signify my heart, my centre.

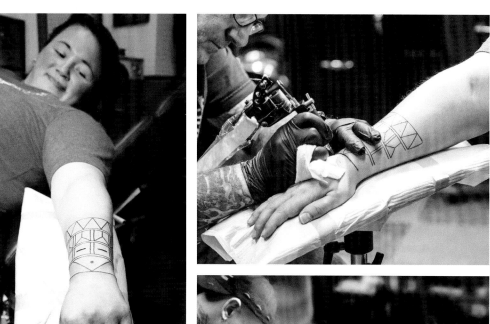

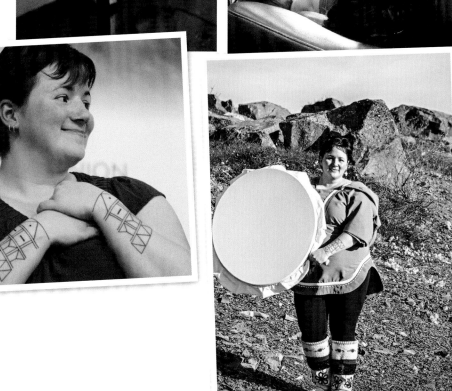

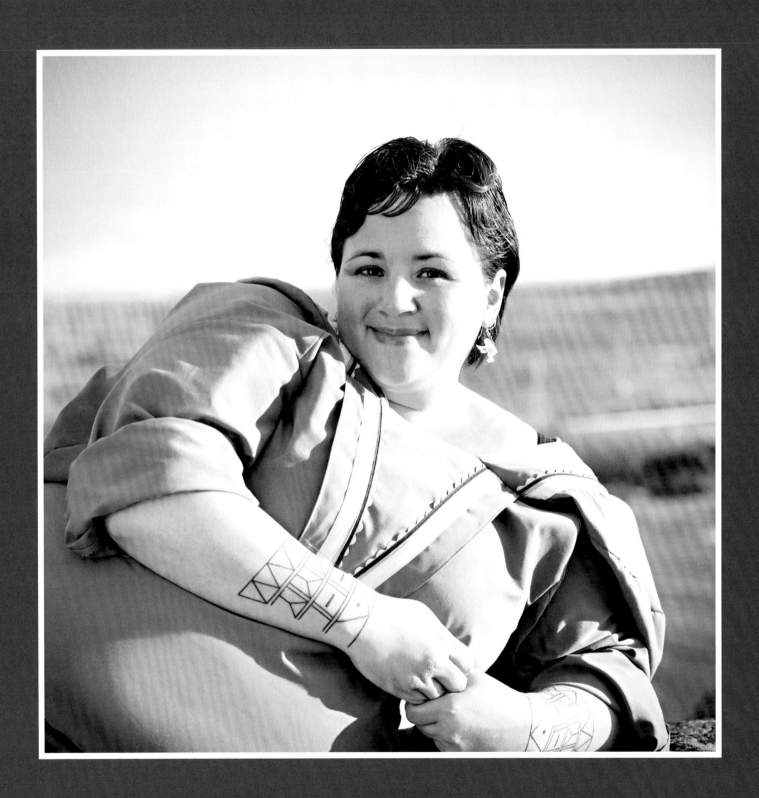

Wynter Kuliktana Blais

While attending the University of Alberta, I was so fortunate to have met Alaskan Inuit professor and performing artist Tanya Lukin-Linklater.

During one of her performances, she whispered, "I am like my ancestors and my children come after me." Immediately, those whispered words became a part of me.

I am so grateful to have been raised surrounded by many bold and humble women who came before me. My grandmother inspired me with her perseverance, my mom amazed me with her dedication and determination, and my aunts each enthrall me with their own uniqueness.

I often sat and listened to their memories of the women who came before them, always intrigued by the conversations of their grandmother, great-grandmother, and aunts. It was evident that I came from a strong line of beautiful women.

The relationships and the emotional connections I feel with the women in my life and the women who came before me were often unexplainable and indescribable—until I sat in that large and very dark performance hall and heard Tanya's whisper: "I am like my ancestors and my children come after me." Those exact words encompass my desire to understand the respect that I have for the generations before me.

"Finish your homework and study for your exams."

"Grab an *ulu*, we are working on Grampa and Dad's caribou today."

"Don't forget to do your house chores after school."

"Pack your camping bag, we are off to goose camp for the weekend."

"Have you sent in your applications for college yet?"

"You will return home from college just in time for spring harvest."

I've been raised trying to understand the balance of two worlds that my parents provided to me, and I am grateful. I am now the mother of two beautiful children and I am often easily consumed by a contemporary lifestyle.

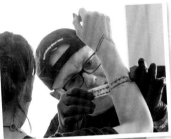

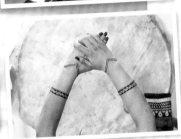

As a working Inuk mother, I understand that my stresses and my uncertainties continue to revolve around this contemporary society. I understand that the women before me also had complex stresses and uncertainties of their own. I understand that regardless of the challenges, these women before me persevered and always maintained beauty within themselves. Understanding our similarities and our differences, I choose to honour my ancestors, I choose to honour myself, and I choose to honour my children.

I am anxious and so excited to express through traditional Inuit art the connections and respect that I have for my ancestors, to express the ongoing challenges I will encounter trying to maintain and understand a balance of our culture in today's society for myself and my children, and to have the reminder to always embrace my beauty as an Inuk woman.

"I am like my ancestors and my children come after me." I am grateful to have this opportunity to express myself through the revival of traditional Inuit tattoos.

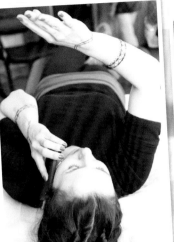

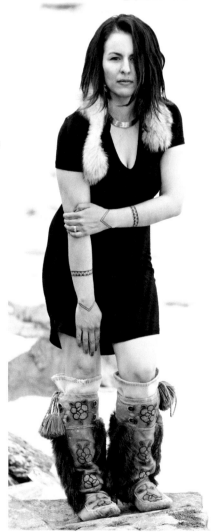

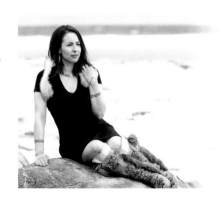

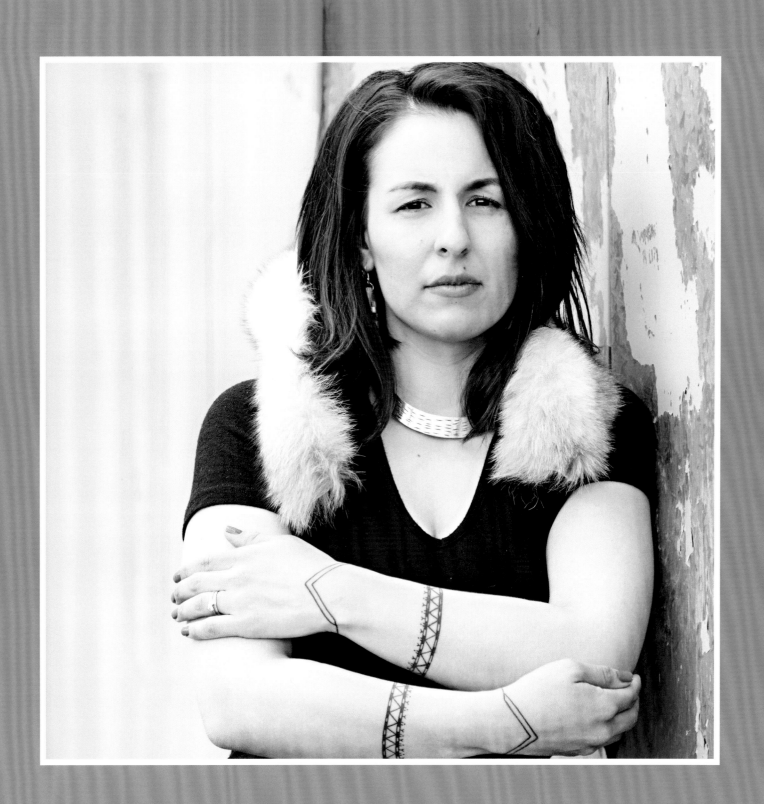

The Westwood Family

Three generations of women from the Westwood family embrace the Inuit tradition of tattooing.

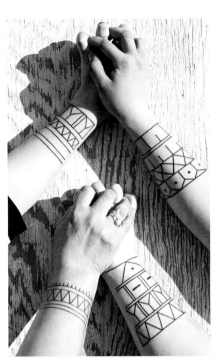

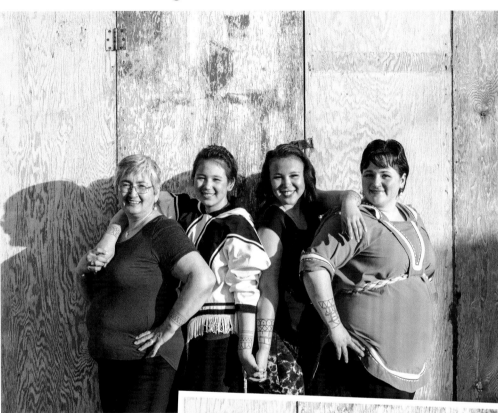

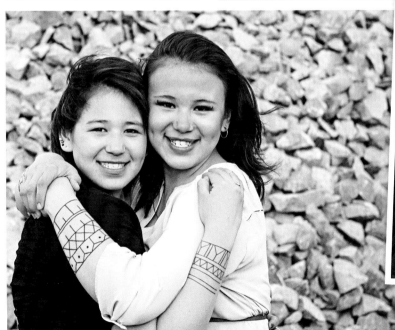

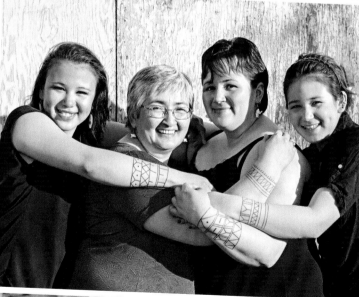

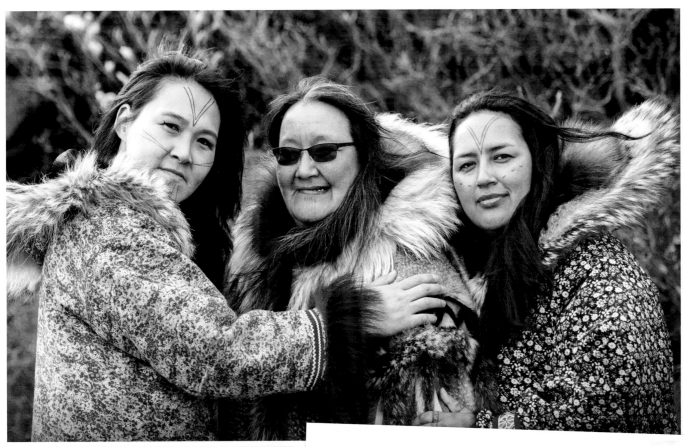

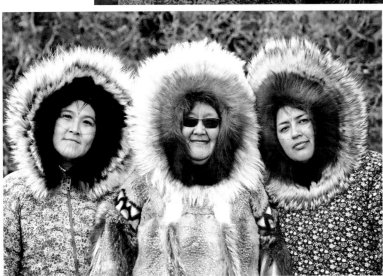

Kitikmeot women in traditional Mother Hubbard parkas.

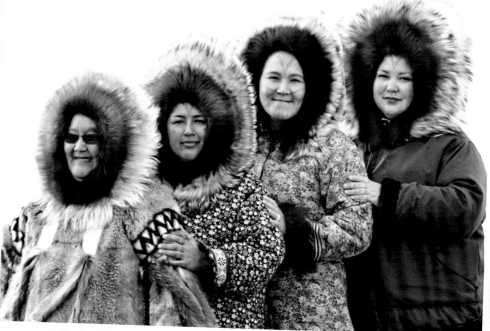

Going Forward

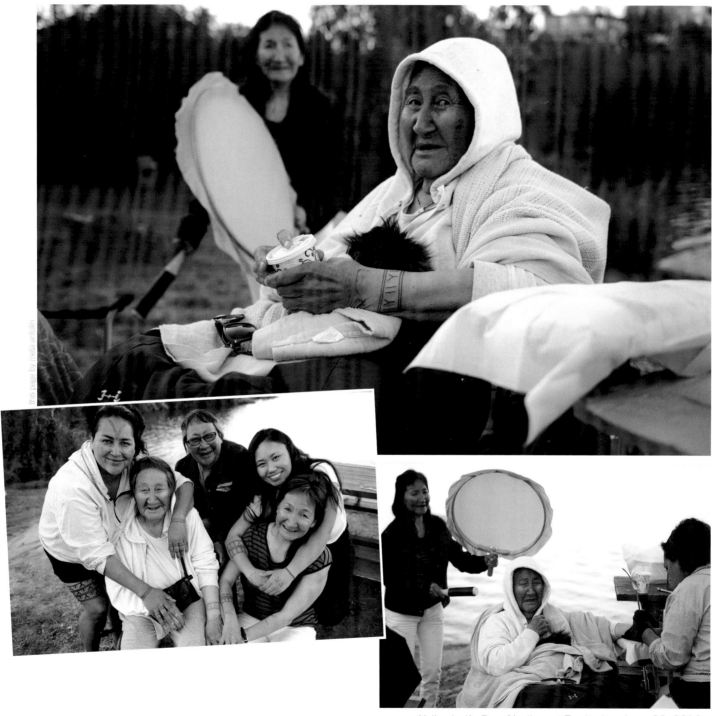

This page by meta antolin

Yellowknife Bay, Northwest Territories, June 28, 2016.

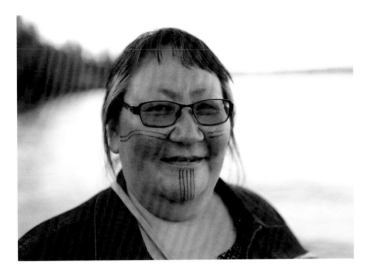

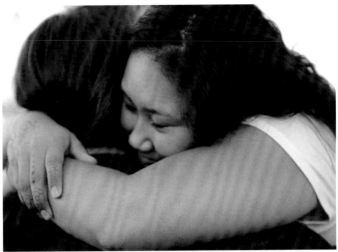

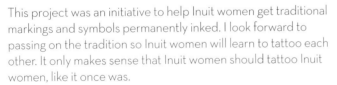

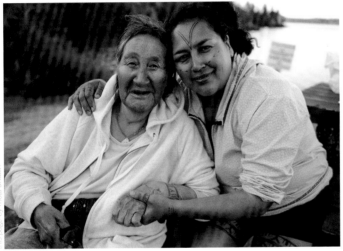

This project was an initiative to help Inuit women get traditional markings and symbols permanently inked. I look forward to passing on the tradition so Inuit women will learn to tattoo each other. It only makes sense that Inuit women should tattoo Inuit women, like it once was.

Here you see the Kudlak family, whom I had the pleasure of tattooing after the Kugluktuk project. These are hopefully the first of many women across the Arctic who will get to experience the rebirth of the traditional Inuit tattoos.

This tattooing practice was taken away from our people by colonialism, missionaries, and residential schools. In some areas of the North, the tattooing tradition was lost for up to four generations (100 years). During the project, we had two families in which three generations got their personal traditional markings and symbols.

The markings are more than ink put into our skin; they reconnect us to our ancestors and tie us to our future, a connection that unites our Inuit womanhood from near and far in a deep bond.

From the beginning of the project to now, I have tattooed Inuit women from the ages of thirteen to seventy-three. Here you see the Kudlak family from Ulukhaktok: grandmother Mary Kongoatok Kudlak; her daughters, Emily Niakoaluk Kudlak and Julia Haugaaq Ogina from Cambridge Bay; and her granddaughters, Koral Eukiana Kudlak from Uluhaktok, and Jaime Dawn Kanagana Kudlak from Yellowknife. It was an overwhelming experience; emotional and powerful. I never dreamed I would tattoo a seventy-three-year-old elder.

I hope to be tattooing for a long time, as it comes naturally to me. I would like to see more generations within families embrace this tradition proudly. I love seeing the pride and confidence of the women who wear their tattoos—not for popularity or attention, but for our culture and people.

There are many strong, silent Inuit who may be shy and timid about speaking up. The ink gives us strength in our presence, adding to our voices and balancing our inner strength with outer. The tattoos have our ancestors' spirit, which gives us the power to lead a better path.

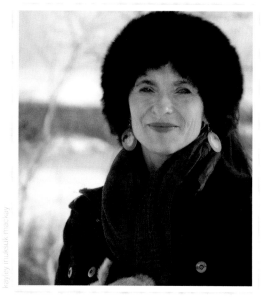

I am Meta Antolin. In my work as a graphic designer and photographer, I creatively organize information to represent people's stories on a printed page. Every project is important, but some are so much bigger than the people who put them together.

Hovak's single vision and drive to launch the Inuit Tattoo Revitalization Project involved many people who recognized the importance of reviving this cultural expression unique to Inuit women. It was an honour to design this book.

This book is a testament to how the strength and the determination of one person can create positive change rooted in both honouring and overcoming the past to build the future. I hope it serves as an archive for each woman who reclaimed her right as an Inuk to mark her personal story on her skin in the almost-lost tradition.

I watched in awe as Hovak mastered tattooing skills with her teachers, tattoo artists Denis Nowoselski and Marjorie Tahbone. I learned so much as I worked alongside Cora DeVos, whose eye for beauty and ability to draw out a subject's confidence produced the stunning portraits that appear on these pages. But most of all, I was moved and humbled by the raw emotion I witnessed as these women reclaimed this Inuit tradition.

Glossary

anaanattiaq: Inuinnaqtun word for grandmother.

atigi: Inuinnaqtun word for parka.

Copper Inuit: plural noun; the native Inuit people who were known to use copper in tools and weapons, located between Cape Parry, Queen Maud Gulf, southern Victoria Island, and Coronation Gulf.

Copper Inuk: singular noun for Copper Inuit.

Eskimo: name given to the Inuit by southern Indigenous groups, referring to raw-meat eaters in their language. Not politically correct; many Inuit today resent this term.

hikhigalik: Inuinnaqtun word for a parka made from the skin of a ground squirrel.

hikhik: Inuinnaqtun word for ground squirrel.

Inuinnaqtun: a dialect of the Inuit language, spoken mostly in the Kitikmeot area (central part of Nunavut).

Inuit: plural noun meaning "the people"; a group of Indigenous peoples from the Arctic regions of Alaska, Canada, and Greenland.

Inuk: singular noun form of Inuit.

Inuktitut: a dialect of the Inuit language, spoken mostly in the eastern part of Nunavut.

Inupiaq: Inuit from northern Alaska.

Kitikmeot: Kitikmeot region is an administrative region of Nunavut, Canada, in the Central Arctic. It consists of the southern and eastern part of Victoria Island and includes these communities: Cambridge Bay, Gjoa Haven, Kugaaruk (Pelly Bay), Kugluktuk (Coppermine), Taloyoak (Spence Bay), Bathurst Inlet, Umingmaktok (Bay Chimo).

Kiowa: a Native American tribe that currently resides in Oklahoma.

nattiq: Inuinnaqtun word for seal.

Netsilik region: an arm of the Arctic Ocean lying west of the Gulf of Boothia, the northernmost part of the mainland of North America on the Boothia Peninsula.

nuna: Inuktitut word for land.

Nunavut: Inuktitut word meaning "our land"; a vast territory in northern Canada.

qulliq: Inuinnaqtun word for a traditional Inuit lamp used for cooking, heat, and light.

tunniit: Inuktitut word for tattoos.

tuulliq: Inuinnaqtun word for loon.

ulu: all-purpose Inuit women's traditional knife.

Umingmaktok: Inuinnaqtun word meaning "like a muskox"; a settlement formerly called Bay Chimo, located near Bathurst Inlet in the Kitikmeot region of the Canadian territory of Nunavut.

Yup'ik: Inuit from southwestern and south central Alaska.

Yupik: Inuit from St. Lawrence Island in the Bering Sea.

Author's Note

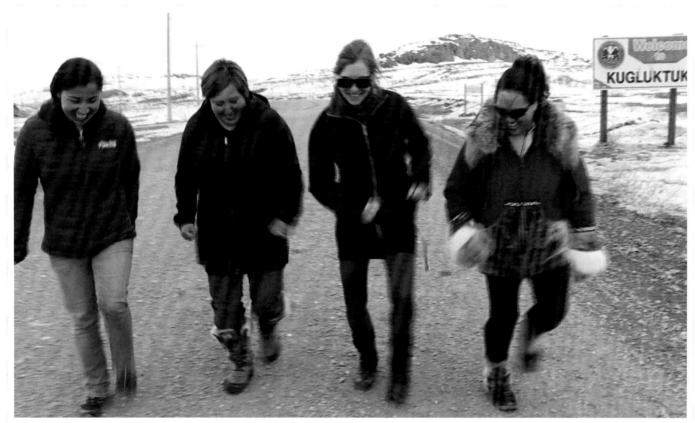

iman kassam

Many women (even non-Inuit women and men) are asking to get traditional Inuit tattoo symbols and markings. There are different points of view on this. These are my feelings, which many others share.

This tradition of tattooing was one of many that were taken away from Inuit when missionaries came to the North, and during residential school days. We were taught and made to feel ashamed of our culture. It is for this reason that my focus is to give back to our Inuit women; they are my priority.

We have many women who yearn to be a part of our strong culture and are still healing from the loss of so many of our traditions. We are trying to find our Inuk identity.

This is not a trend; it is a rite of passage with guidelines. These tattoos are our beliefs and pride. Please be patient and respectful toward our women as we explore the meanings of our markings.

I hope people can understand why many of us feel this way and that you will stay away from this form of appropriation—even if you, as a non-Inuk, get permission from an elder or another Inuk.

Let our Inuit women go through this special period of taking back something so important to our culture. Let them enjoy the beauty of expressing their Inuit identity.

You may feel strongly about a loved one who is or was Inuk and want to be part of this powerful movement. You can still participate and honour them through educating others on the significance of cultural appropriation and sharing what you know.

With the knowledge I have gained of traditional and modern methods of tattooing, for now, I will only tattoo our Inuit women. In my heart I feel that, because this tradition was taken away from us and hasn't been practised by an Inuk woman since the early 1900s, I'm honouring our Inuit women. I feel Inuit women should be first in line and have the first opportunity to get the special markings and symbols.

— Angela Hovak Johnston

• Wales

• Nome

ALASKA

YUKON

BRITISH
COLUMBL